Date Fishe Collection Of the

INTRODUCTION TO Pastel and acrylic

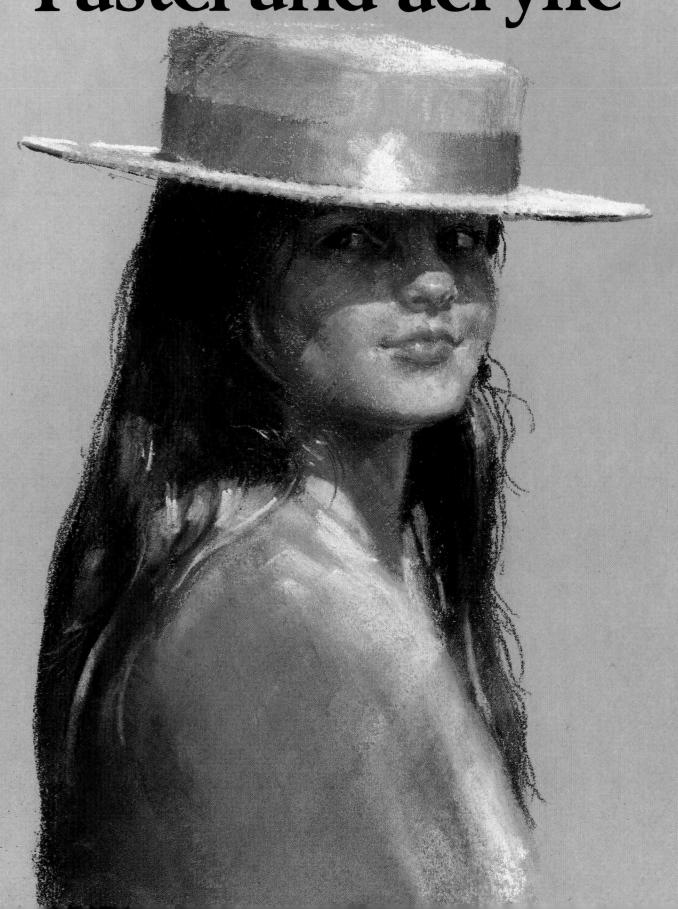

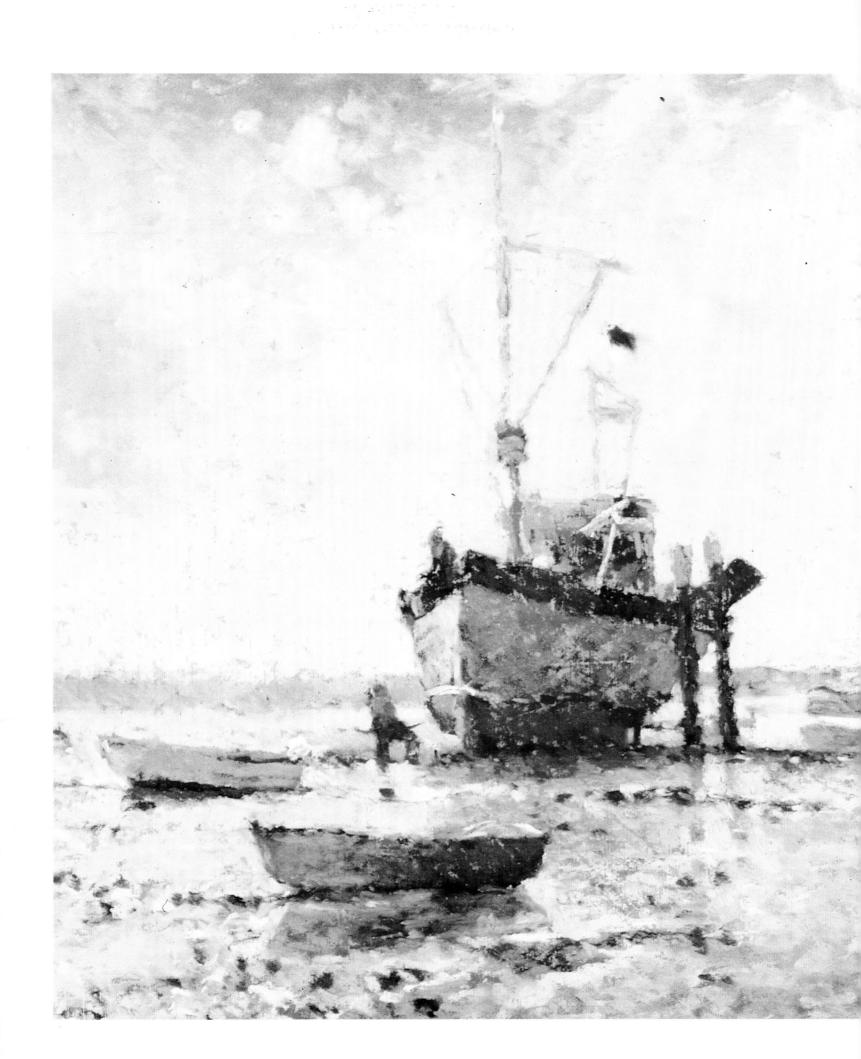

INTRODUCTION TO Pastel and acrylic

Ronald Pearsall

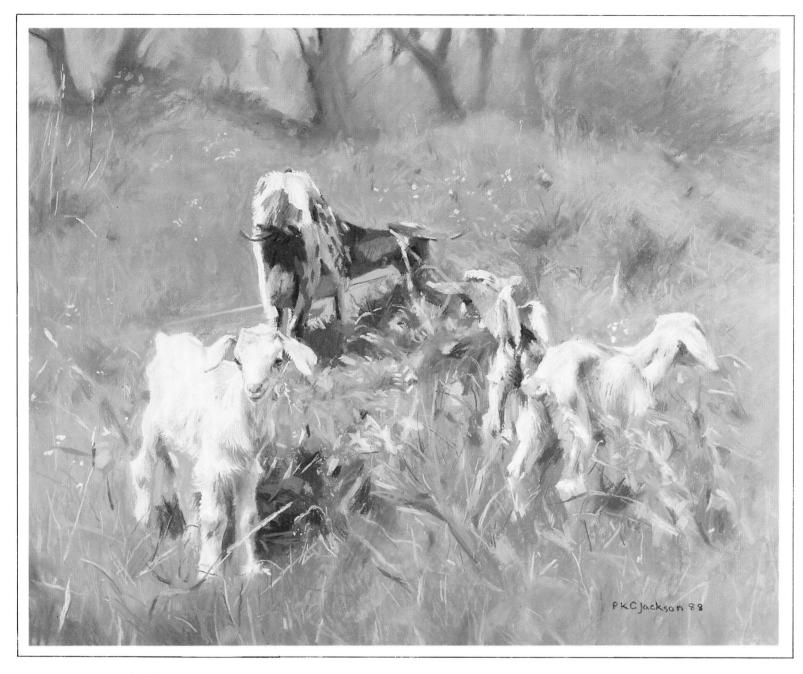

Published in the USA 1995 by JG Press Distributed by World Publications, Inc.

The JG Press imprint is a trademark of JG Press, Inc. 455 Somerset Avenue North Dighton, MA 02764

ISBN 1-57215-084-X

Copyright © 1990, 1993, 1994, 1995, Regency House Publishing Limited.

All rights reserved. No part of this publication may be reproduced, stored in a retrieval system, or transmitted, in any form or by any means, electronic, mechanical, photocopying or otherwise, without permission in writing from the publisher.

Printed in China.

Above: Grazing Goats by Ken Jackson. This interesting composition uses sophisticated pastel techniques.

CONTENTS

Introduction	1
What Are Acrylics?	12
What Materials Are Needed?	12
How Do I Start?	16
Pastels	33
What Are Pastels?	36
What Materials Are Needed?	36
How Do I Start?	40
The very first steps	4]
Beginning the picture	4]
Applying the pastel	43
Drawing with pastels	48
Landscape and townscape	56
Oil pastels	71
Figure studies and portraits	72
Still life and flowers	88
Closing stages	90
Mounting and Framing Pastels	92

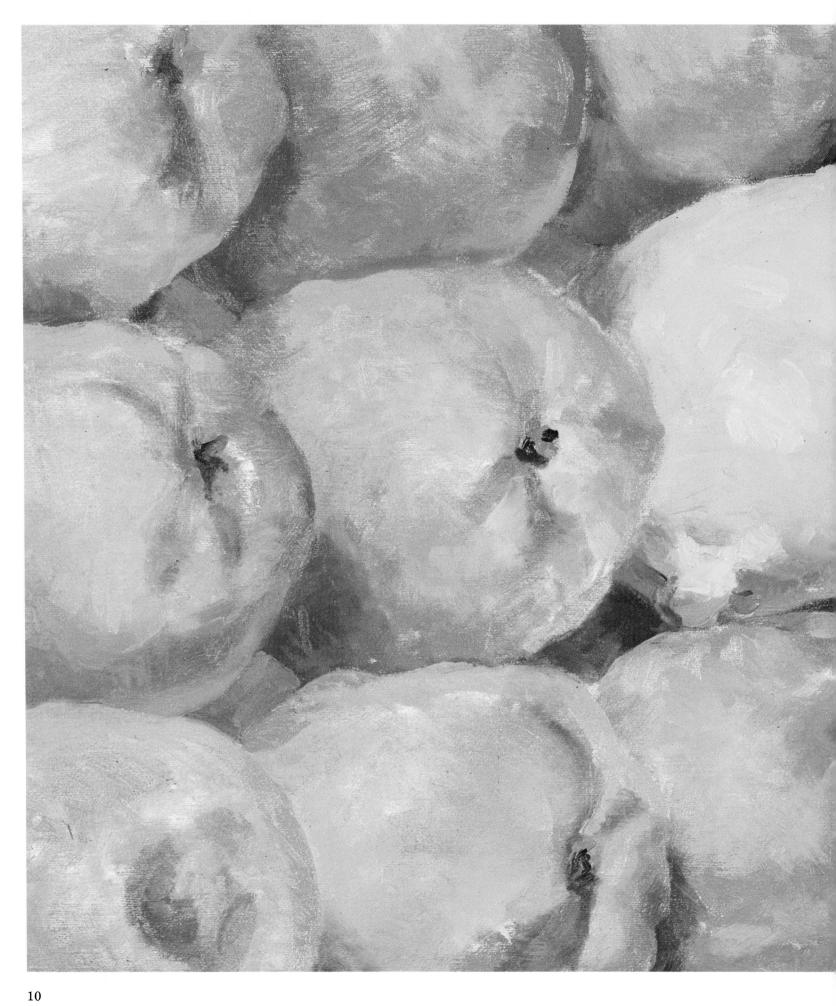

Introduction

Why, it might be asked, are acrylics and pastels coupled together? There is a very logical answer. The use of both these wonderful mediums can create instant pictures. You don't have to spend time waiting for the paint to dry, and you can go over what you have done time and time again until you feel that you have it right.

And bringing acrylics and pastels together serves to emphasize that painting methods can be combined. You can use pastels with watercolor, you can use acrylic with pastels. There are only two divisions – mediums to use with water and mediums to use with oil.

Acrylic paints are newcomers to the art scene, a product of modern technology. Their scope is virtually unlimited. In a recent art scandal a number of fake early Picassos were sold at vast sums, but how were they finally recognized as fakes? They were painted in acrylics and were dated forty years before acrylics were discovered!

Those who have not discovered the delights of pastel have a treat in store for them. As with acrylics, pastels can do almost anything. You can use them as drawing tools, you can use them flat, that is on their side, and thus create masses of color, you can go over a pastel drawing with a watercolor brush, and you can use pastel dust dropped onto watercolors or acrylics to create a magical effect. Read on . . .

Left: This very simple acrylic of oranges by Denis Barker is brought to life by a lemon interestingly placed.

WHAT ARE ACRYLICS?

Acrylics are the only new paint to have come onto the market for centuries. Introduced in about 1962, they are as versatile as it is possible to imagine. They can be used thickly like oil paints, or in transparent washes like watercolours. They can be applied to almost any surface whether it be paper, panel, cardboard or canvas. Their main attribute is that they dry very quickly and are ideal for those who work at top speed and like to see a finished picture in half an hour. They dry too quickly for some, but the drying speed can be slowed down with a retarder, and there are all kinds of additives such as mediums and texture pastes to suit every taste, though normally water is used as the painting agent. Van Gogh would have loved acrylics. Some established painters are suspicious of them despite the many claims (justified) made for them.

It may seem unusual to share a book between pastels and acrylic, but they have many resemblances, obvious and less obvious. The main one is ease of working and the possibility of doing a picture very rapidly indeed, in a few seconds if need be. Pastel, being dry, can be worked over with subsequent layers immediately; and so can acrylic, being very quick drying. With both, there is a temptation to regard a quick flashy picture as a good picture; it is almost impossible to avoid making a picture by putting on colour at speed. Both pastel and acrylic can be mixed with other mediums to create something wholly new, and both pastel and acrylic are virtually permanent. Unlike oil paints, where asterisks on the tube denote the degree of permanence, you can be pretty sure that acrylics last, and we know that pastels from the eighteenth century have come down to us with their colours and their bloom absolutely intact.

Much of the advice and recommendations regarding pastels are applicable to acrylic, and rather than repeat information about perspective, about the necessity of looking, assessing, and painting what you see, not what you know is there – all of which can be read in the section on pastels – the advice on acrylic will tend towards the practical application.

WHAT MATERIALS ARE NEEDED?

Paints These come in fairly large tubes, as acrylic paint is often used in bulk, and there is a very large range. Because acrylic dries very rapidly the top should always be kept on.

Mediums and Glosses These can be used at will, and impart a lustrous texture. Used with water, acrylic is slightly matt.

Retarder This slows down the drying process, but never to the same extent as one normally gets with oil paints. To dedicated users of acrylic the adding of a retarder defeats what to many is the medium's great asset – rapid drying and the consequent ability to apply coat after coat within a few minutes. Acrylic paint is opaque when used thickly, and obliterates what has gone before, except when diluted and used as a glaze.

Texture Paste An optional extra, as you can build up texture anyway, and using thick pigment you can get what textures you want.

Primer This is a thick white paint rather like household undercoat and is used to paint on an absorbent surface, though size is better (and cheaper).

Varnish Acrylic varnish is a curious milky substance, and when used has the effect of completely obliterating the picture surface until it starts drying, when it is quite transparent. There is no reason why the traditional varnishes as used in oil painting cannot be used.

Brushes Nylon brushes only should be used. More people have discarded acrylic because of clogged brushes than for any other reason. Acrylic paint dries not only on the picture, but on the brushes, and only methylated spirits will clean them and only then if caught in time. The remedy is simple. Always keep the brushes in water, not point down but fairly flat in a brush tray. Nylon brushes will last for years if this practice is adopted. Do not be put off by nylon brushes; they are superb, even the smallest ones marked 00. If you really want a rough paint texture, you can use bristle, but the same advice applies - always keep them in water. Some artists still prefer to use sable for fine work, but these will suffer if kept in water continuously. Use the complete range of brush sizes from very large to very small.

Far right: A comprehensive range of acrylic materials by a major manufacturer.

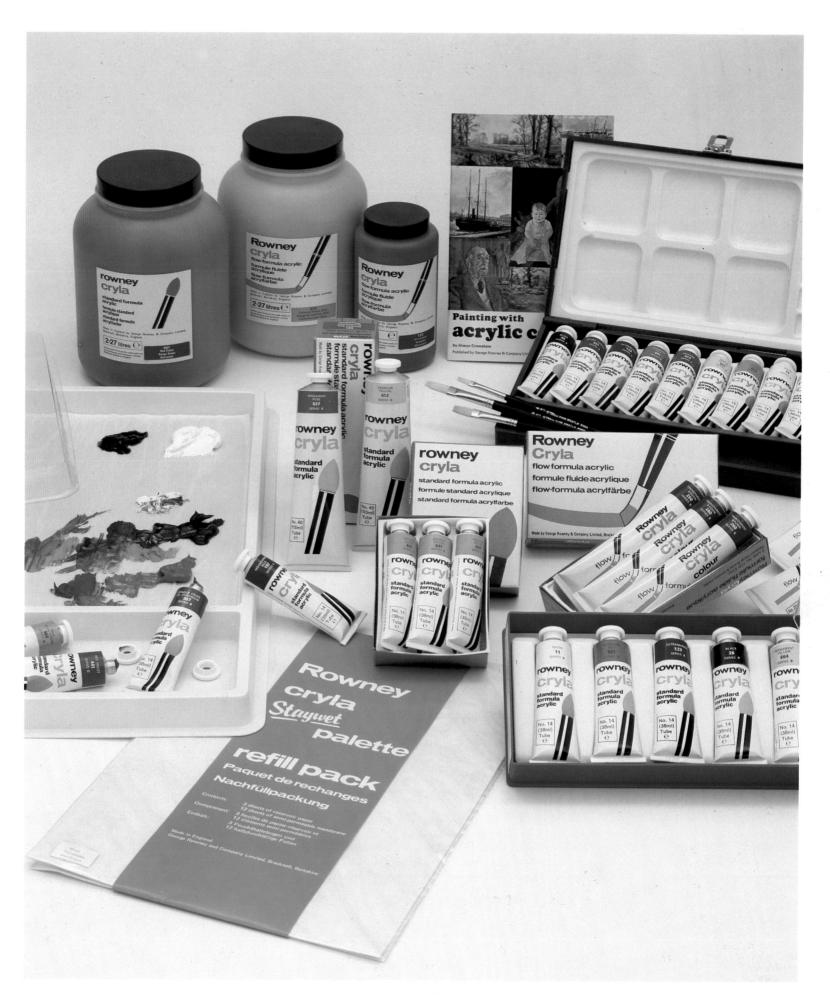

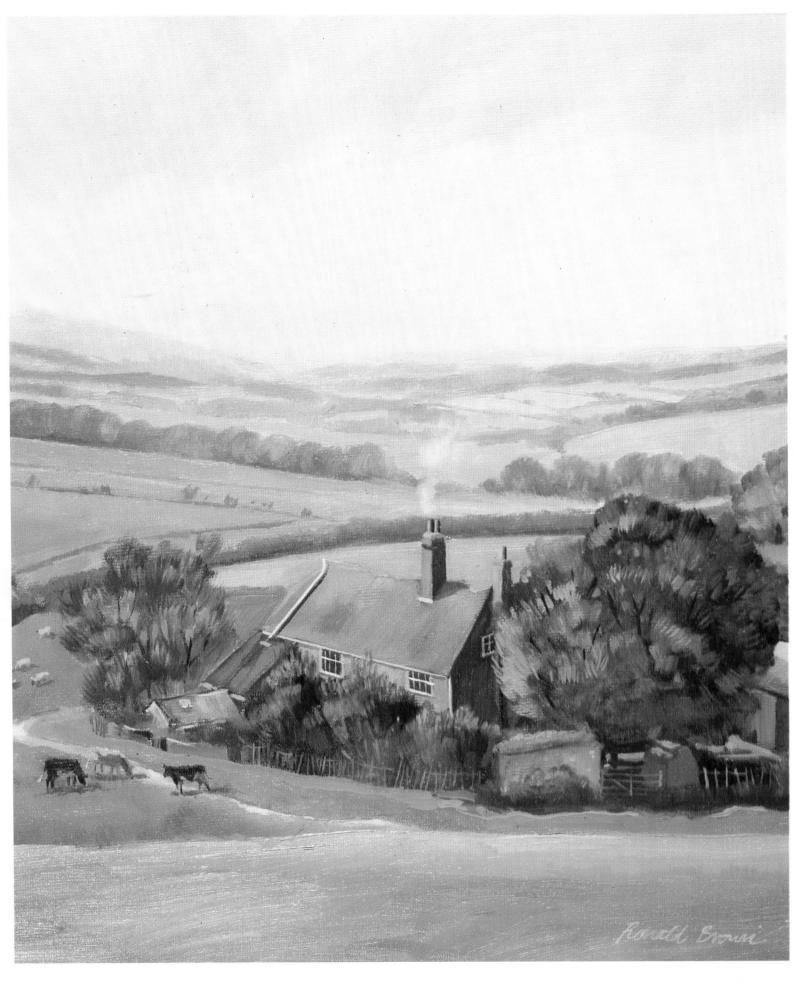

Palette Knives Palette knives come in several sizes, and are useful in acrylics. Do not let the paint dry on the steel of the knife, for although it can be scraped off there is always a danger of damaging the thin steel of the smaller palette knives. Acrylic is ideally suited to palette-knife work, as it is not messy and does not ooze oil all over the place.

Palettes and Mixing Trays There is something on the market called a Staywet Palette, perfect for acrylics for as the name implies it stays wet and stops the paint coagulating. It is worth noting that the bigger a blob of paint in the tray or on an ordinary palette the longer it will take to dry out. In normal use, acrylic paint will not dry out on the palette before it can be used, and if in doubt add water to keep it moist. When acrylic paints start to dry on the palette, a crust forms. The paint can still be used if this crust is prised off gently with the tip of a palette knife.

Paper Almost any type can be used, but cartridge paper is as good as anything and, for those who like to use their paint smooth, mounting board or white card is suitable. If you are using acrylic paint fairly thickly, water-colour paper is rather an expensive option. Because of the heaviness of the paint, thin paper is not really advisable. Canvas is excellent, but no better than card unless you are keen on using the natural texture of the canvas without overlaying it with too much paint.

Easel Acrylic lends itself to broad handling, and consequently an easel is essential if you like a bold style with lots of bravura

Pencils and Charcoal Because of the great covering ability of acrylic, any medium you use to lay down your design will be obliterated by the paint (unless you are using it in thin water-colour style). If you are painting in several layers, making use of acrylic's drying rapidity, remember that you may need something to apply a design or an outline on to the *earliest* layers. In this event, bear in mind pastels or a felt-pen, something that will carry a line over paint ridges better than pencil.

Water Containers No less than three, one for clean water, one for less clean water, and one to splash the brushes around in between changes of colour. The brush tray *should* hold the brushes not at that moment being used, but if you are working at top speed it is more convenient to pop the brushes into the medium-clean water and trust that the points won't be damaged.

Masking Tape A very useful material, suitable for fixing paper to a drawing-board instead of drawing-pins, and also of great help in painting straight edges (the tape is laid alongside the area to be covered, and is then taken up when the paint has been applied, taking with it the ragged edge of paint and leaving an absolutely straight edge). For irregular areas, including circles, the masking tape can be stuck around the area to be covered. Of course, as masking tape comes in rolls of varying thickness, the tape will be buckled, but that does not matter.

Drawing Board As always, this is an optional extra depending on what you are painting on (technically known as the ground), but essential if you are using an easel and paper.

In addition you will add all kinds of odds and ends to your working material from time to time, and do not be afraid to improvise. A pair of dividers may come in useful if you want to compare one line or area of paintwork with another or to calculate distances between point A and point B. You may find that you want to 'work up' your textures, and that the usual range of brushes do not give quite the effect you want. Two handy stand-bys are old toothbrushes and old shaving brushes, which give a texture of their own, unrepeatable with ordinary custom-made paint brushes. You can achieve interesting textures in acrylic by scoring the paint surface while still wet, and the point of a pair of dividers will do this, as will a knittingneedle or one of the blades of a pair of scissors.

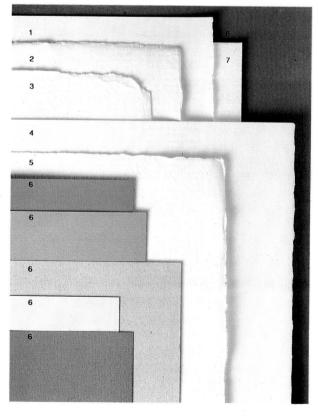

Far left: This Ron Brown acrylic landscape painting uses all the materials and principles described in this book, including aerial perspective and over-painting.

Left: A selection of papers: 1. RWS 90; 2. Green's Pasteless; 3. Whatman's Rough 200; 4. Fabriano NOT 90; 5. Whatman's HP 140; 6. Ingres; 7. Bockingford.

HOW DO I START?

You can pick up acrylics as and when you like. There is little mess, though, if you are working on the flat, you should use sheets of newspaper to protect the working surfaces adjacent to your paper or canvas from any splashes of paint. This newspaper is also useful to try out colours you have mixed. Go through your brushes, and check that they are not clogged up. Make certain that you have plenty of water and always keep brushes-in-action in water, ideally not on their points or bristles. A Staywet Palette is really not a luxury, but a necessity if venturing into acrylics with any kind of commitment. It consists of a flat plastic tray divided into two sections, one large, one small. The small is partly filled with water and it holds the brushes. The large section has two sheets of paper on the bottom, blotting-paper and a type of paper which lets water through but remains taut and unbroken. The paint is applied on top of this paper. When these paper sheets have become plastered with paint or are otherwise unusable, refills can be purchased at any art shop. Both the palette and these refills are very reasonably priced. On top of the plastic tray is a close-fitting polythene cover; this makes the tray airtight when not in use.

Water from the tap is gently poured into the tray until the two sheets of paper are soaked through. The blotting paper is always at the bottom. Surplus water is then poured off. Now lay out your colours, remembering to replace the tops of the tubes immediately the paint has been squeezed out. You may prefer the colours in a set order, from light to dark, or higgledypiggledy. There is no need to clear the paint off after each session; in doing so you may tear the paper and make it useless, though it will stand a good deal of ordinary wear and tear. If you are using a medium or a retarder keep it near at hand, and in a small tin or receptacle rather than in the original bottles or jars, and dole it out as you need it.

If you are working standing up, make certain that the easel is at a convenient height and that the tripod legs are not too splayed out. Of course, you can sit at the easel; a stool or wind-up office chair is better than a chair with arms. Position the easel so that you get good light, even if artificial, which is sometimes better as it does not change during the course of a painting session.

As always, get something down before you get transfixed by the blank paper, but if you are exceptionally modest and feel that blank paper is wasted on you, get something down on a

sheet of newspaper or some old wrapping paper. Acrylic is an ideal medium for newcomers to painting, because whatever you put down can almost immediately be obliterated by more paint.

You may like to get the feel of acrylics and work out for yourself how much water you need on the brush, whether you prefer to use a medium with the paint rather than water, and how the paint goes down compared with other sorts of paint you have used. You can do this whether making a picture or merely doodling; making some kind of picture is certainly more interesting.

When you take up acrylic, you may not want to do it with an audience, so you will not want to try it out in a life class or outdoors. If you are indoors, perhaps a still life, either imaginary or created from the objects near at hand - a loaf of bread, some fruit, maybe a jug. You can draw these in pencil fairly roughly, just sufficient to place the shapes on your working surface, and then put in your patches of colour. If you are not as yet too certain about your handling of colour, use a few colours, or perhaps just black and white, which gives you all the tone you want. Get the shapes more or less right, and then put in the edges as loosely or tightly as you wish. Try to make the picture hang together, and try not to make it too bright. Sometimes it is an effort to keep the painting low in tone (lower than it is in real life), but muddy colours have their own appeal and in the 1950s and 1960s they were the favourites among contemporary artists of the new realist school.

Perhaps you would prefer to kick off with a landscape, either imaginary sparked off by a photograph or one of your own drawings. If you have already tried watercolour and have found that you can get along with it, do a watercolour first, and use acrylic on top of that. Or use watercolour washes to put in the feel of a landscape without being precise, and then build upon this, using transparent acrylic washes as if you were continuing to paint in watercolour. Then you may, or may not, use opaque acrylic on top of that.

There is no best way, in any medium, to paint a picture; there are convenient ways, there are ways that suit you and you alone, and to find out whether acrylic is a medium you need to persist with — after spending the money to buy the equipment and materials—you want to be aware of the techniques, even if you do not use them. Many of the techniques associated with acrylic painting have been lifted from oil-painting methods. One of these is the 'wet on wet' technique, which means exactly what it says, applying wet paint on to wet paint, which helps

The versatility of acrylic techniques is shown below.

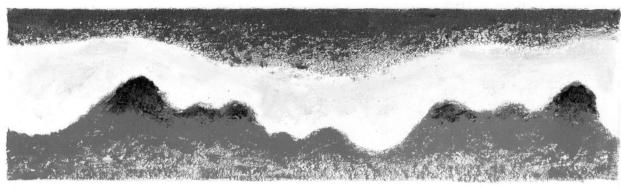

This shows the effect when colour is used fairly dry and a stippling is employed.

Acrylics can be used as a wash as with watercolours.

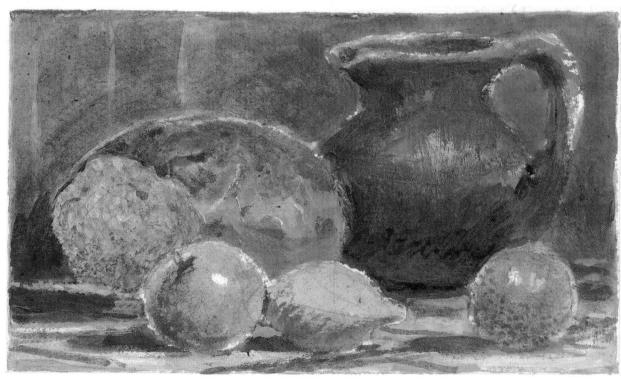

A simple example of what can be achieved by using the above methods.

to merge colours, and is very useful for skies. You can use the acrylic very wet, or you can add retarder. The reverse of transparent acrylic paint is the use of texture paste. You may wish to build up areas of pigment so that the painting is almost like a relief, and the effect can be quite impressive, especially in the foreground of a picture. Being white, texture paste when mixed with paint tends to weaken the colour, and if you want darks it is best to lay down the texture paste first and add the dark colour when the texture paste is dry.

When the surface of the ground is porous, such as an untreated canvas, acrylic paint can be used thinly as a stain, but for general purposes this has only a limited appeal. In the first instance, you will probably want to use the full body of acrylic, either rough finish or smooth. When this surface is dry, there are a number of subsequent techniques to use. You can scumble, meaning drawing a dry brush loaded with paint across the dry surface, so that some adheres and some does not. It is no good trying to do fine work using this technique, but it adds texture to a painting and is good for doing water ripples. Scumbling using a dry brush and very little paint is ideal for mist and fog effects, and also to obscure partially a distant scene which may have become too prominent.

Another worthwhile technique is glazing, which is putting a transparent or semi-transparent wash over the existing picture. The colour should be heavily diluted with water or medium (which will make the glaze more shiny) and it is perhaps best applied with a soft brush, whereas scumbling is most effectively done with bristle or nylon. There is no limit to the number of glazes you can apply, and by a shrewd medley of glazes you can alter the whole character of a picture. You can experiment with taking some of the glaze out of certain areas using a piece of rag, and you must not think that glazes are necessarily light in colour. There is no reason, for dramatic effect, why black should not be used as a glazing colour.

When you are putting on a glaze or using acrylics in a diluted form do not expect quite the same feel as using watercolour wash. As I have said, acrylic is not a subtle medium, so do not expect the same kind of effect. Be prepared for a little annoyance when the colour dries out more quickly than you had anticipated. However, this is more than compensated by its covering properties; you can put white on black and confidently predict that the black will not show through.

All subjects can be tackled the same way. It does not matter what they are, whether land-

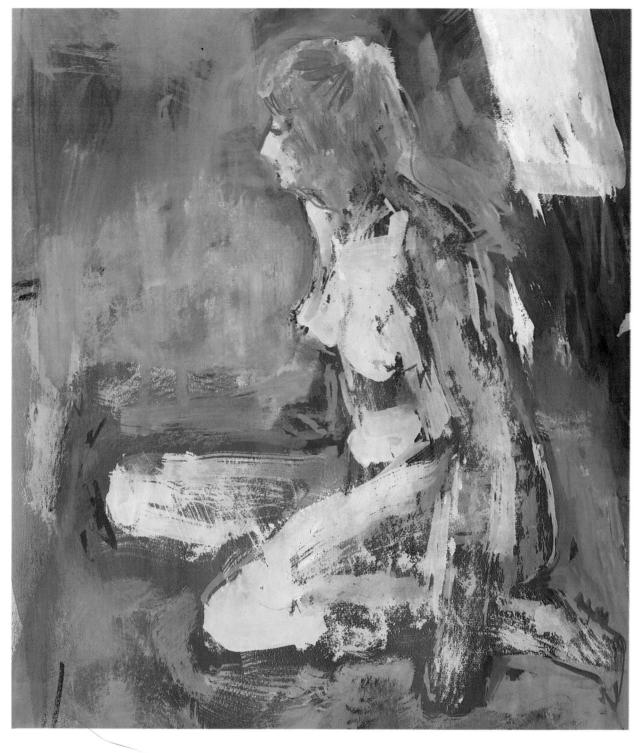

Left: In this very quick study of a nude the artist has shown that with acrylics you can overpaint darker areas without any 'showthrough'.

scape, seascape, still life, or figure work. You do not have to change the approach because there is something different – maybe something unfamiliar – in front of you. And any subject can be made as easy or as difficult as you wish.

One of the simplest kinds of picture is a straightforward seascape. No complicated shadows or intricate drawing are involved. It can be done on any surface, and we'll assume that you are using inexpensive card. But this is a deceptive project, for though it will be kept basic and straightforward it will illustrate the capabilities of acrylic and the possibility of

transforming one kind of picture into something entirely different. Naturally this can be done with any kind of painting medium, but not so conveniently with others.

Pin or tape the card onto the drawing board and, using a T-square or a ruler, draw a straight line across in pencil two-thirds of the way down. This is the sky-line. Mix blue and white, not much blue, plenty of white, using sufficient water to make the mixture run, but not too much to make it translucent. There is no need to make a bland mixture; let bits of white remain untouched by the blue. With a medium

Diagrams, far left: The effect of using acrylics as watercolours, leaving white paper as the highlights. In these diagrams the artist has not applied any white paint. or large brush, depending on the size of the card, begin applying the colour from the top down, left to right, not too fast, letting the mixture slide but controlling it. Take it to the sky-line; if you drift past the line it does not matter.

While the top of the sky is still damp, try to put more blue into it, fusing it with the original colour. Add clouds, not absolutely white but muted with perhaps a touch of yellow ochre or raw sienna. At the bottom of the clouds add shading, a touch of burnt umber or similar.

Mix a sea colour. Select your own blend — blue plus green, perhaps with added browns and yellows, perhaps a touch of red, which tones down all greens. Paint the bottom third of the card, making a neat join with the sky colour. If you have overlapped the line with sky colour, go over it with the sea colour. You can emphasize the sky-line by tracking across with the edge of a flat soft brush before the paint dries. Add further darkish colour in the foreground. You can suggest waves with flecks of white, with a hint of shading below.

Put in a land feature on the sky-line, dark colour, perhaps with added blue to give the feeling of distance. Do this with a small pointed hair brush, outlining the shape and filling in. The sky will be dry by this time so the overpainting will be crystal clear without fudging.

In the centre of the picture, or near the centre, put your ship. Depending on ability it can be a sailing ship, a ship with funnels, or (as there is nothing in the picture to suggest scale) a rowing boat. This serves as an accent. It can be any colour that differentiates it from the sea. Using the softest brush (even 0000 which is tiny) put in highlights on the deck of the ship, or bow, or on the waves at the base of the ship. Add birds (flat Vs) at will.

Thus a simple picture, unpretentious, but neat and recognizable. We will now add to it, by providing interest in the foreground. If you have mixed a good quantity of sea colour you will have some over, so add to it a reddish colour, perhaps vermilion, perhaps burnt sienna; if too bright, add a touch of black. These are for rocks. With the tip of a soft brush outline a structure of rocks in the foreground, and begin filling them in, with some parts medium strong, others darker. Keep aside a little dark paint to add separately. Decide which way you would like the light to come from; if from left, paint in shadows on the rocks away from the light source. These can be as simple or as complicated as you wish. If there are sharp edges, you can assume that the light will catch these with full force, so with a small brush put in delicate highlights.

You can then put in dashing waves, basically

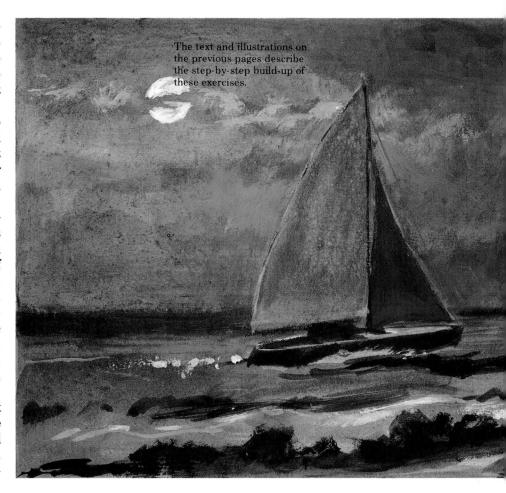

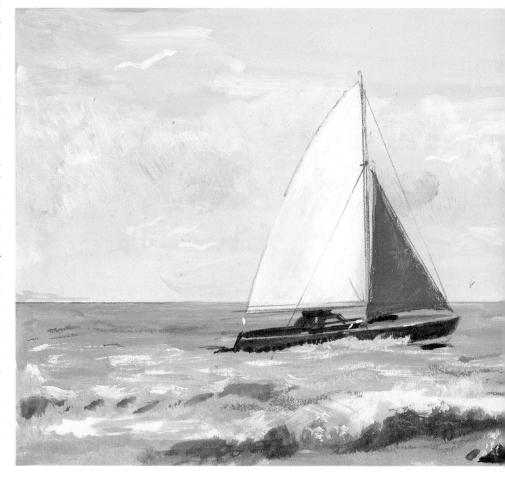

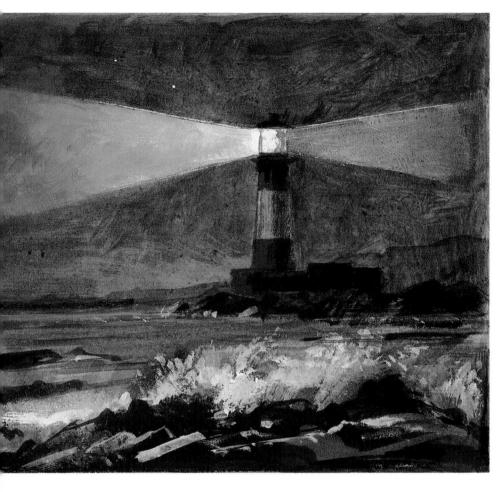

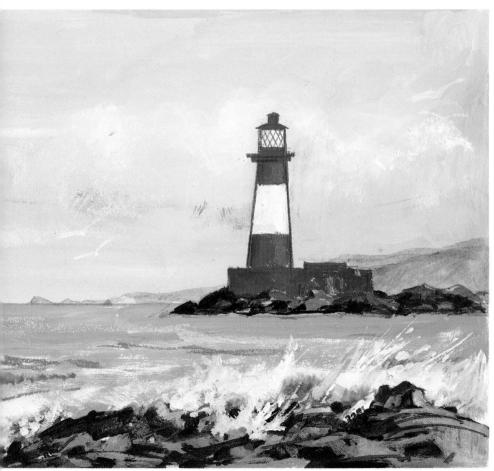

whitish, but not absolutely white as otherwise it will nullify your highlights. Remember that waves have shadows, so darken the waves at the bottom; waves nearer the foreground can have light crests so that they are silhouetted against those behind. You can have a series of waves, each painted on top of the previous set, wet-on-wet, or on dry. You have rocks but no absolute scale; the rocks can be any size, so you specify what size they are by putting in a lighthouse. This can be a vertical shape, slightly tapering, outlined in pencil maybe by the use of a ruler or drawn in with the point of the brush. The shading on the side of the lighthouse must match the direction of the shading on the waves. As lighthouses are usually in cylindrical section, grade the shading, so that the tones come in various vertical densities. Near the top will be the lamp. You can light the lamp. But first of all you have to turn a daytime scene into a night-time scene. Mix a thinnish blue-black so that it is close to the density of a watercolour wash, and from the top left of the card cover the whole area with the possible exception of the lighthouse. Add a small muted yellow circle in the sky to indicate the moon, remembering that this will cast shadows. Paint in the lamp with a glowing yellow, adding a flick of white, then mix a yellow wash.

This can be laid around the top of the lighthouse in a halo fashion, or it can be put in a segment through the sky and over the dimly lit waves. If the underlying dark overall tint recently applied is too strong, reinforce the yellow wash with another one, and maybe another one until you have got the strength right. Bring up the lighter side of the rocks where they are in the moonlight, darken the shadow side still more, for the shadows of moonlight can be very crisp.

What time of the night is it?

Perhaps it is approaching dawn, so we concentrate on the sky-line, adding a pale wash with a trace of crimson, reinforcing it if it is not powerful enough. We tone down the moon, and add a tinge of pink to the undersides of the clouds. To further the idea that this is our new source of light, the yellow beacon can easily be toned down or taken out by passing over it another dark wash. The top of the sky can be darkened even more, as can the immediate foreground. With the light coming from a different direction - straight ahead - the shadows of the rocks need to be drastically altered. The shadows are now face on. The land mass on the horizon is now a focal point, being so near the light source, and this can be built on, with detail put in so that some of this island is in shadow, some in sunrise.

This demonstrates how easy it is to convert

Left: The final exercise of the finished night scene.

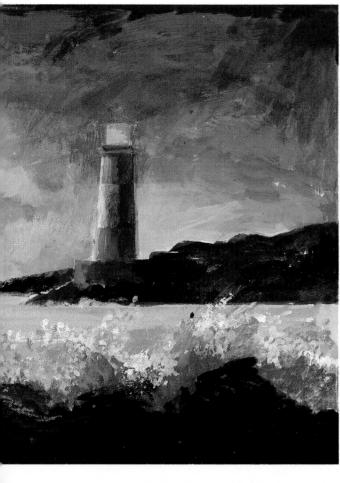

an acrylic, and there is more to come. It is no longer a seascape but a landscape. The lighthouse is no longer that, but a trunk of a tree. The order of transformation need not be fixed. but we can alter the lighthouse by slimming it down, taking out the yellow of the lamp, and extending it right to the top of the picture where it disappears. Further trunks can be inserted across the picture, not too mathematically, in dark brown, just sufficiently toned to be seen against the black background of what was water and sky. The rocks can be converted into ground by softening the contours, altering the shadows, which, as we are at this stage still retaining the sunrise on the horizon, will be those of the trunks. These shadows, perhaps burnt umber with a trace of blue, will extend to the bottom picture edge, flaring out as perspective has to be taken into account. The edges of the trunks will be lighter, and these tones will merge with the really dark ones running up the centre of the trunk.

The sea and the waves are no longer wanted, and neither is the ship, so they can be overlaid with rich pigment in greeny-grey, darker near the foreground, getting lighter towards the skyline. As the ground colour approaches the horizon, contours can be picked out against the pink, and to break up the ground colour trees can be inserted as vague shapes in a dark green, together with hedgerows, always a good feature in a landscape. This will form a great contrast to the sea picture, but it will not be a good picture, however the transition is dealt with, because the frieze of trees running across the picture plane will destroy any notion of composition, even if branches are added to alleviate the effect of all the verticals.

As the tree trunks are occupying too much attention it is necessary to reduce their importance by creating a more interesting foreground. This can be done by suggesting plants or flowers. They will necessarily be subdued in tone because they will be in the shadows of the tree trunks, but nevertheless the tones can be rich, by using oranges and reds with added neutral colours. These foreground features can be enlarged so that they occupy most of the bottom third of the card, and 'spot-lit', reducing all other tones in the picture, so that the tree trunks merge into the background and are no longer intrusive.

The next adventure can be to take out the trees completely, together with the top two-thirds of the picture, and convert the whole thing into a flower picture, adding detail to flowers, inserting blades of grass (remembering that each blade of grass has a bright side and a shadowed side and that individual blades can only be seen in the foreground). Blades of grass

Left: The development of the above exercise into a landscape using the overpainting properties of acrylics to make a continuous painting exercise.

do not go in the same direction, and some cross over other grass. Behind the flowers there can be shrubland, not too highly differentiated, and in the middle distance grass, depicted in changes of tone, not colour, demonstrating the rise and fall of the land. At this stage, some of the picture will belong to a previous episode, and some of it can be kept. You may wish to retain a dark sky; a stormy sky can be dramatic against the greens of grassland. Behind the flowers and shrubs you may care to suggest cottages, in light greys with not too emphatic shadows, and even, with a few stabs of colour, indicate the presence of people.

At this stage you may like to change the centre of interest from the flowers to the cottages, blurring the foreground or throwing it into shadow. Pick out the main details of the cottages, the shadow thrown by the underside of the roof onto the walls, the windows, the doors, maybe indicated by just the shadow of the overhanging bricks or stone above the door or window. The glazing bars of the window may

be seen as the shadows beneath the bars, not the bars themselves. If the cottages are going well, you can spotlight them, perhaps using the palette knife when adding highlights, and blurring everything else, even the sky-line. The blurring can be done by melting compatible tones into each other so that nothing is specific, and if you find it easier use the finger tip instead of a brush.

Continuous art may be a new concept. It is certainly fun, whatever your degree of proficiency. You can change your techniques throughout, using both bristle and hair brushes, applying the paint with the flat of the brush in squares, dabbing it on in stabs and strokes, applying glazes and scumbles at will. A pinky scumble would have worked well in the project when changing the picture from night to dawn.

And adventure and enjoyment are what it is all about. Painting in whatever medium opens a magic door. You may pick up a brush at seven o'clock in the evening. The next time you look at the clock it may be midnight.

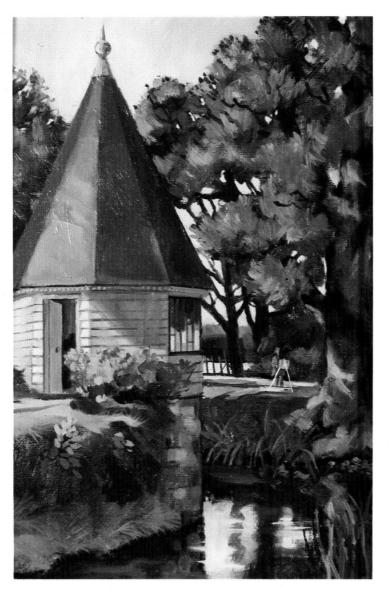

Left: This painting uses all the continuous methods explained in the previous pages.

Top: Figures in a landscape help to indicate scale and enliven the picture.

Above: Detail showing reflections in water.

Far left: The continuous painting exercise is described in the text.

Cobalt blue

Permanent green deep

Burnt sienna

Yellow orange

Raw sienna

Ivory black

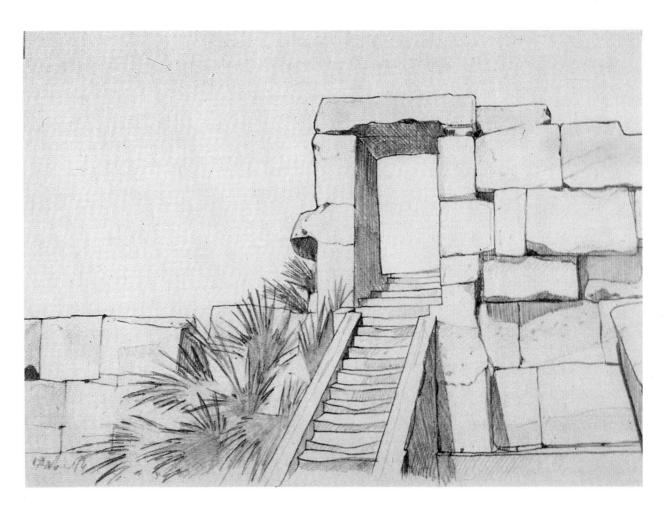

Acrylic can be used as a very dense medium, with good covering power. Notice how the preliminary outline, taken from a drawing, is totally covered by the final painting. Much detail, including shading, can be drawn and painted over, without fear of showthrough.

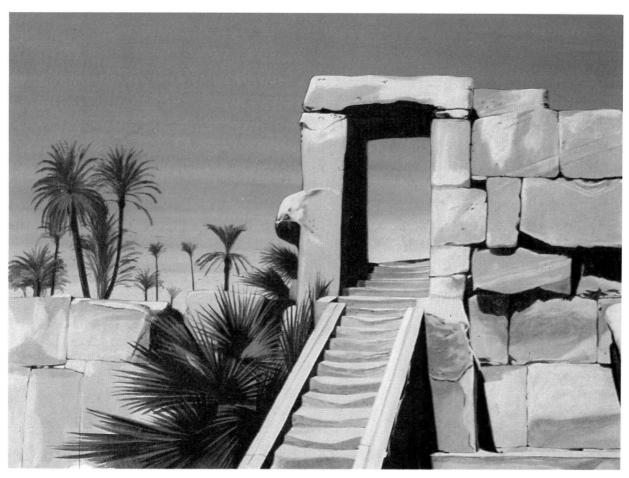

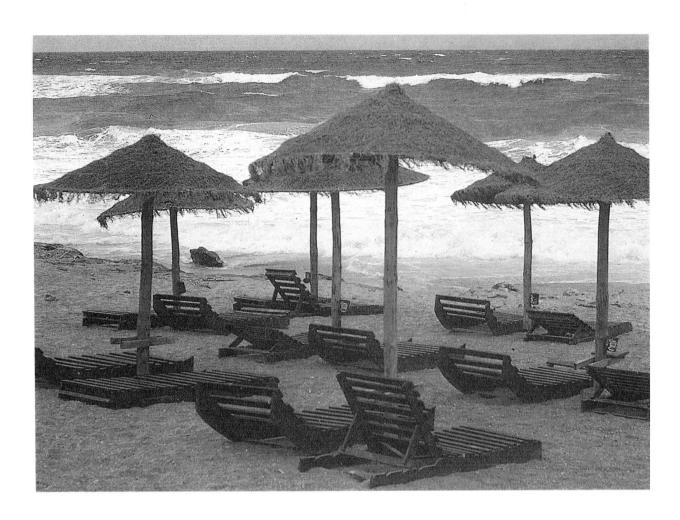

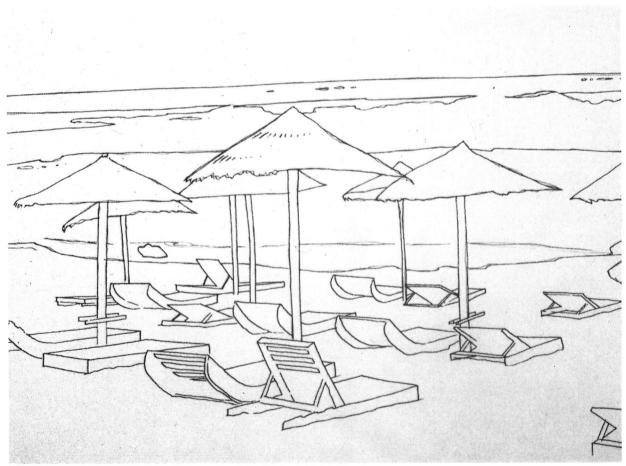

Top: This charming beach scene has been painted from a photograph. Acrylics can be handled, as here, like oil paints.

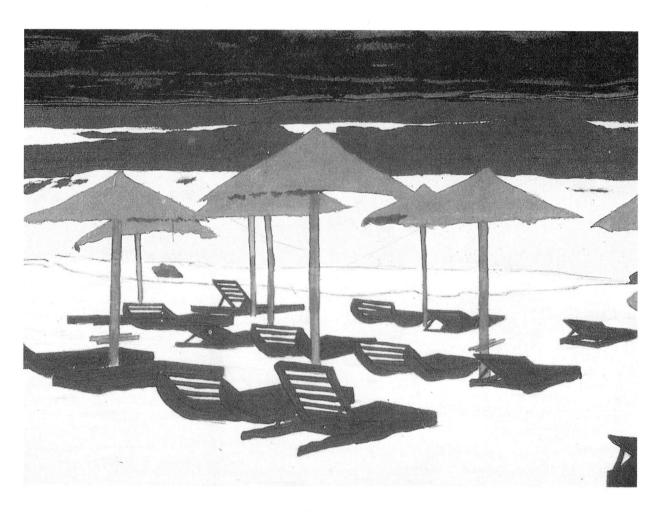

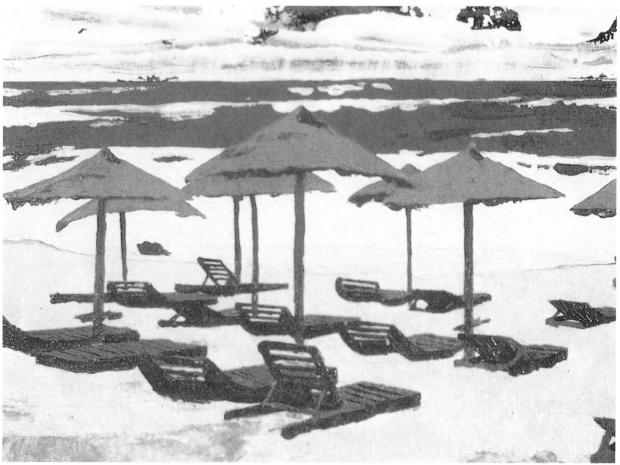

In this painting of a Spanish sunset the artist, rather than trying to re-create the original photograph, has chosen to simplify the shapes and colours, while still retaining the heat and atmosphere.

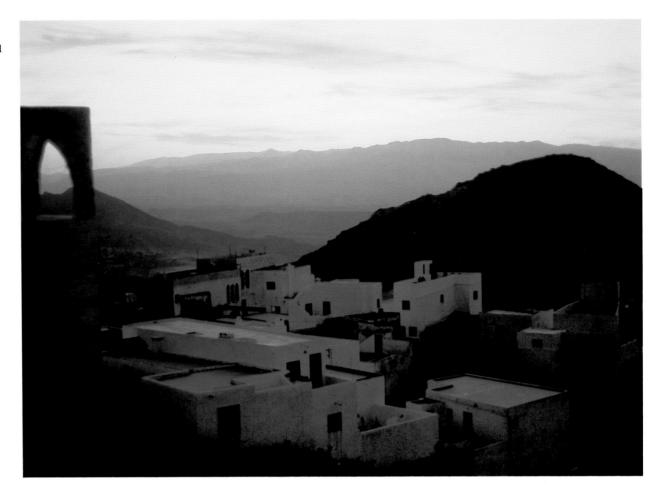

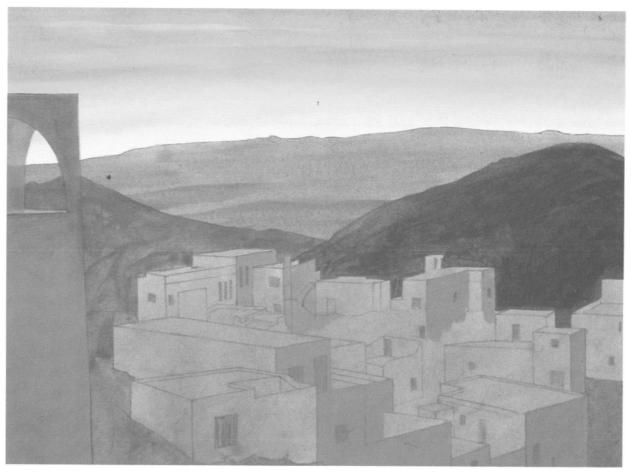

Medium yellow

Yellow orange

Orange red

Medium magenta

Prism violet

Burnt sienna

Black

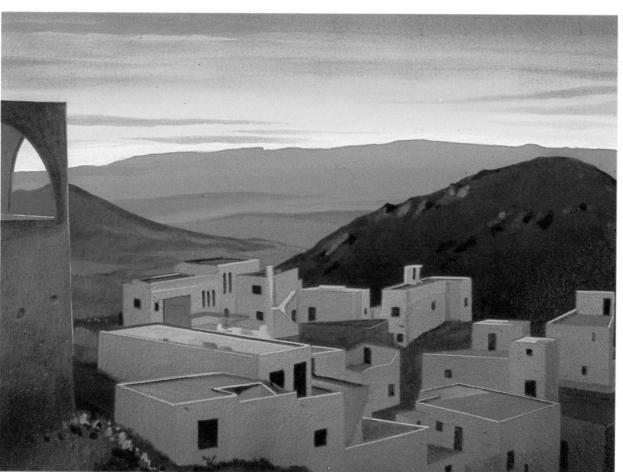

Winter Landscape by Denis Barker is brought to life by its very interesting composition.

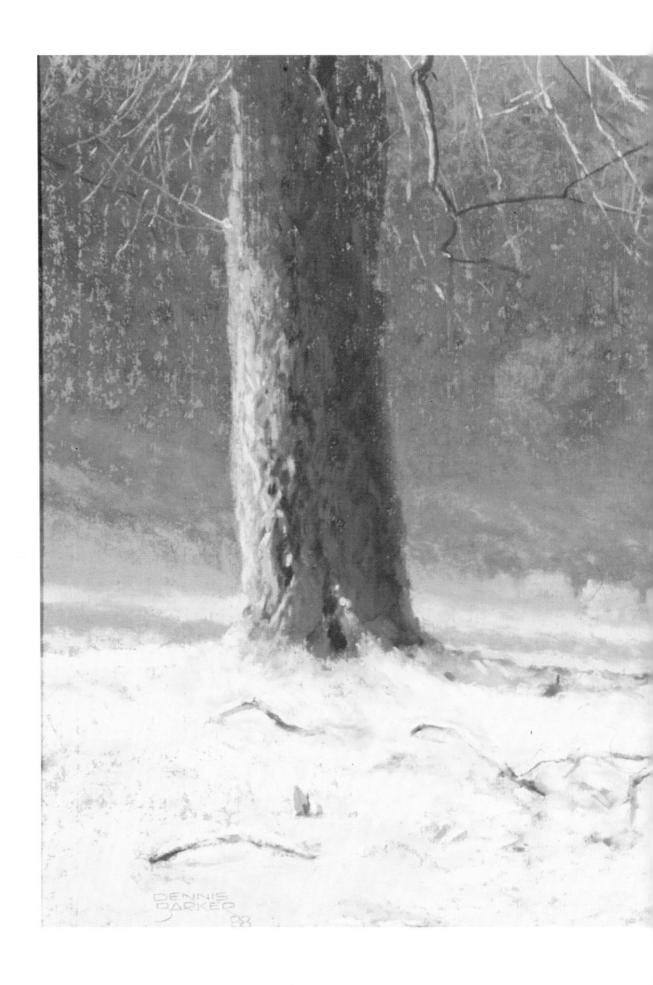

PASTELS

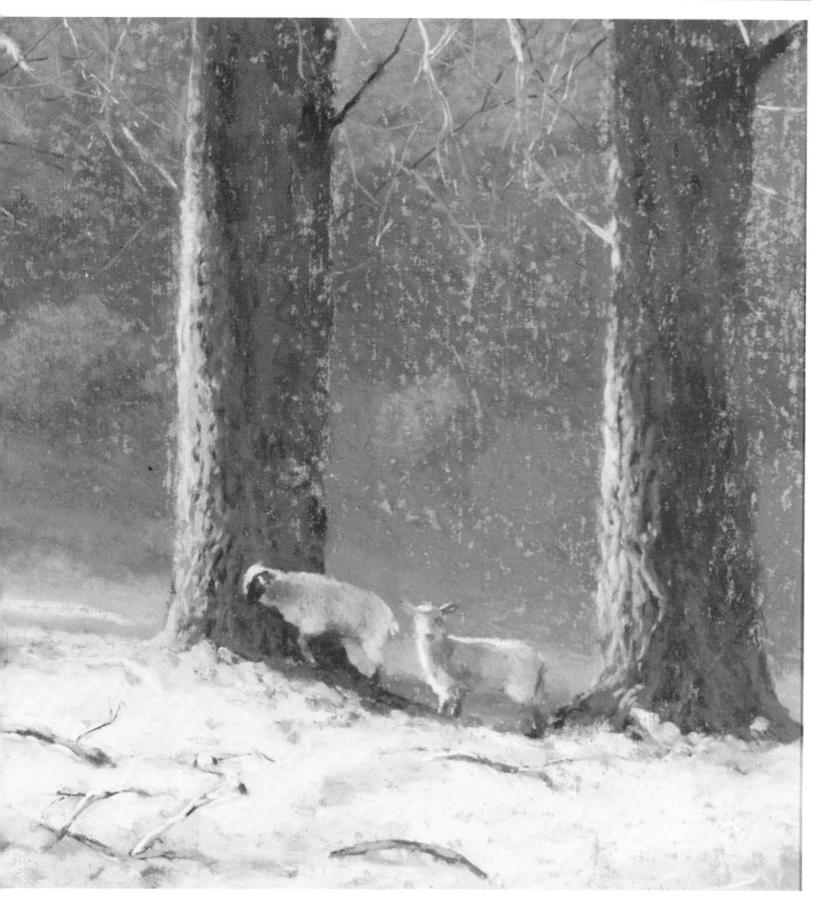

A selection of pastels and accessories shows some of the vast range available.

WHAT ARE PASTELS?

Pastels are powdered colours mixed with water and chalk or oil and chalk, and made into sticks. Some manufacturers put in a binder to stop the pastels crumbling; the softer the pastel, the less binding is used. Water-based pastels are more often used than oil pastels.

WHAT MATERIALS ARE NEEDED?

A Selection of Pastels Pastels are sold in boxes, with a compartment for each pastel, and to stop the sticks rattling about they are protected by a layer of cotton-wool or tissue. There are at least 200 distinct tints, and boxes usually contain 12, 24, 36, 72 or 144 pastels, plus specialized selections for landscape and portrait work. Pastels are also sold singly and, where expensive ingredients are used, prices of some individual sticks are higher than others. There are hard pastels and soft pastels; the soft pastels are usually cylindrical in section, the hard ones square or encased in wood (the extremely useful pastel pencils which can double as coloured pencils). Hard pastels, the most famous of which is Conté crayon, are chalk based. Because of their hardness they are mostly used for preliminary work and detail, and are often used at an early stage in the picture as it is sometimes difficult to apply hard on top of soft pastel if used loosely, though not if rubbed in with the finger tip. Soft pastel, far more frequently used, goes well on hard pastel.

Paper The most popular kind of paper is called Ingres, and it comes in various sizes and colours. It has a slight tooth, which is ideal for picking up the pastel powder. Any kind of paper can be used, such as watercolour paper, brown wrapping paper, cartridge paper, cardboard, and even sandpaper.

A Drawing Board Although not absolutely essential, a drawing board is very useful, as the paper can be fixed to it with drawings-pins or Scotch tape (or masking tape). Some artists prefer to work on a surface which has more 'give', in which case a pad of folded newspaper is placed under the pastel paper.

An Easel Again, this is a matter of choice. Some artists prefer to work on a flat surface, but when you are using an easel the surplus pastel powder falls off and makes the surface less messy. There are many kinds of easels, large studio easels, fold-up easels, and table-top easels. They have to be modestly robust as a good deal of pressure is applied to the paper when pastels are being used, and an easel which slides away as it is being used can be annoying, as well as bewildering to the sitter if you are doing a portrait.

Charcoal Charcoal comes in thin sticks, and is very useful to sketch out the preliminary design. Charcoal does not have any real bite, and does not overwhelm the pastel. It also mixes very well with pastel, and can be taken out with an eraser or even the finger tip. A putty rubber and a piece of bread are two of the best forms of eraser, but a putty rubber does get very grubby when used with charcoal. You can also use a chamois leather. Charcoal is usually bought in made-up packs, so the buyer cannot really select the sticks he or she wants, but charcoal without a hard core is the better.

Pencils Pencils can be used to make preliminary sketches, and a softer rather than a harder pencil is better (2B or 4B though some prefer HB, which is neither hard nor soft and is the ordinary office pencil). Pencil in general should not be used in the final stages of a pastel picture, as it shows up shiny.

The effects which can be obtained from various grades of pencil.

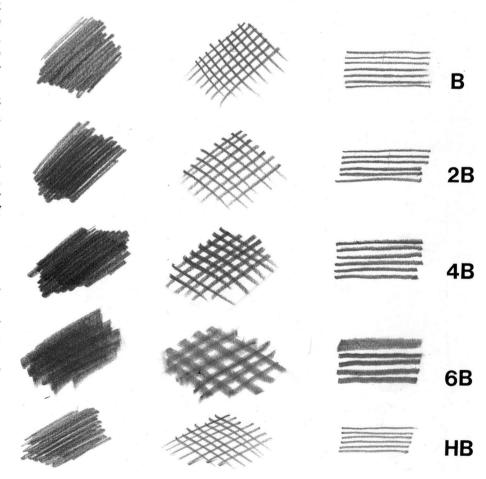

Pastel Pencils Pastel pencils are quite new, and are merely pastels in the form of a pencil, useful for fine work, but rather tiresome as the wood has to be constantly shaved away. Coloured pencils are also very useful and come in a great range of tints. Mostly they are compatible with pastel, especially those which dissolve in water, as pastel does.

Stumps or Torchons These are compressed 'pencils' of blotting-paper or a similar substance, used for blending the pastel colours on the paper.

Tissues Tissues can also be used to blend the pastel colours on the paper, but they are useful to have about as when using pastels the hands tend to get powdery.

Cotton Buds Again these are very suitable for blending pastel colours, especially for fine work. They can also be used to apply pastel powder where the pastel itself is too clumsy.

Erasers The best kind of erasers are putty rubbers; ordinary pencil erasers are too harsh, and can mess up the tooth of the paper. The use of any kind of eraser should be kept to a minimum, except for preliminary sketches. When pastels are applied layer on layer, an eraser can ruin the whole thing.

Fixative Some artists prefer not to use a fixative, as they think it takes some of the freshness away, but the risks of smudging a pastel picture are great enough to make a fixative very useful. Fixatives are sold in liquid form, and used with a mouth-spray (two narrow metal tubes on a hinge, and used with the tubes at right angles), or in aerosol cans (more convenient). Full instructions go with the cans. When the fixative is used, the pastel picture goes very dark, which can be alarming the first time, but it dries out in a few minutes without any great colour change taking place.

Brushes Both soft and bristle brushes can be used in association with pastel, to blend the dry pastel, or used with water to turn the powder into a paste (the word pastel comes from the word paste). This paste can be drawn over with dry pastel. Bristle brushes can impart interesting textures to the picture surface. Some artists do not use brushes at all, and it is entirely up to you.

This is the basic equipment for painting in pastels, but there are extras which you can add at will. If you wish to do a detailed underpainting on which you will put your pastels later, you may want to do this in watercolour,

acrylic, pen and ink, or felt pen. All these go well with pastels, simply because they go with water. The thing is to experiment, to find out what suits you. It may be that the sight of a clean sheet of paper is daunting. In that case, get something down on it right away, anything, even a splash of colour by using a sponge (which can spark off an idea for a picture, just as looking at a fire does).

Pastel techniques. The *left* column shows direct application by rendering for maximum density. Centre column: The effect of cross-hatching. Right column: the subtle use of pastels by blending in and spreading with a finger.

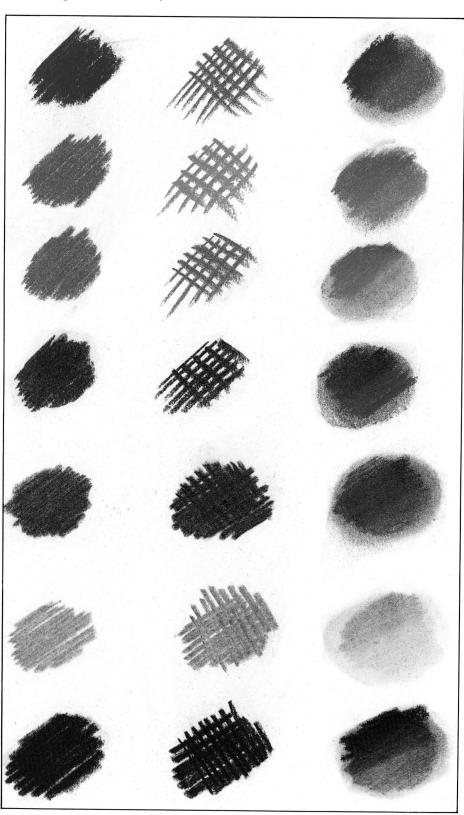

The ingredient essential to the success of this pastel painting by Denis Barker is correct perspective, with the bales of wheat straw in the foreground, the barn in the middle distance, and the horizon giving a natural feeling of depth.

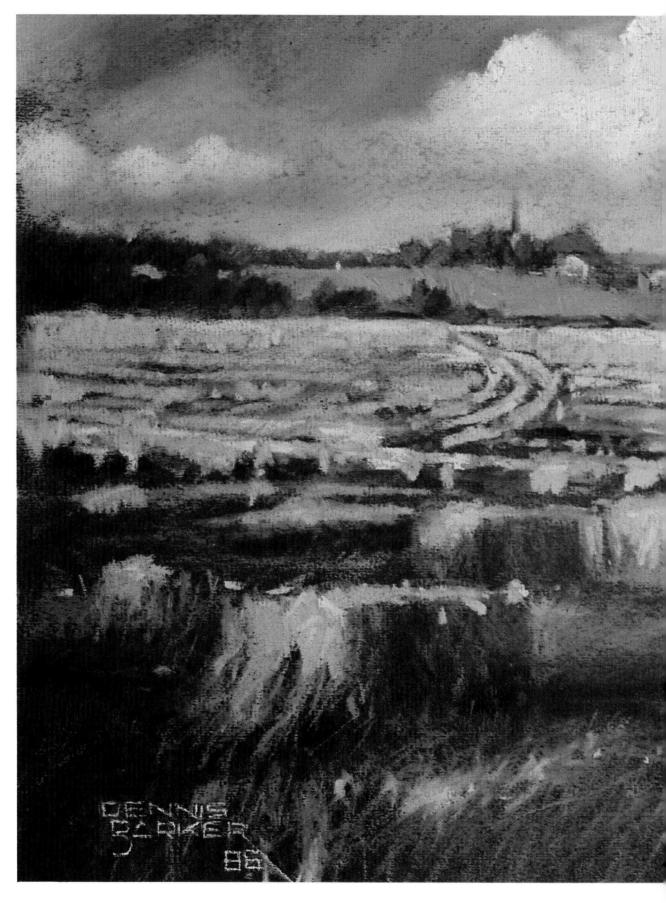

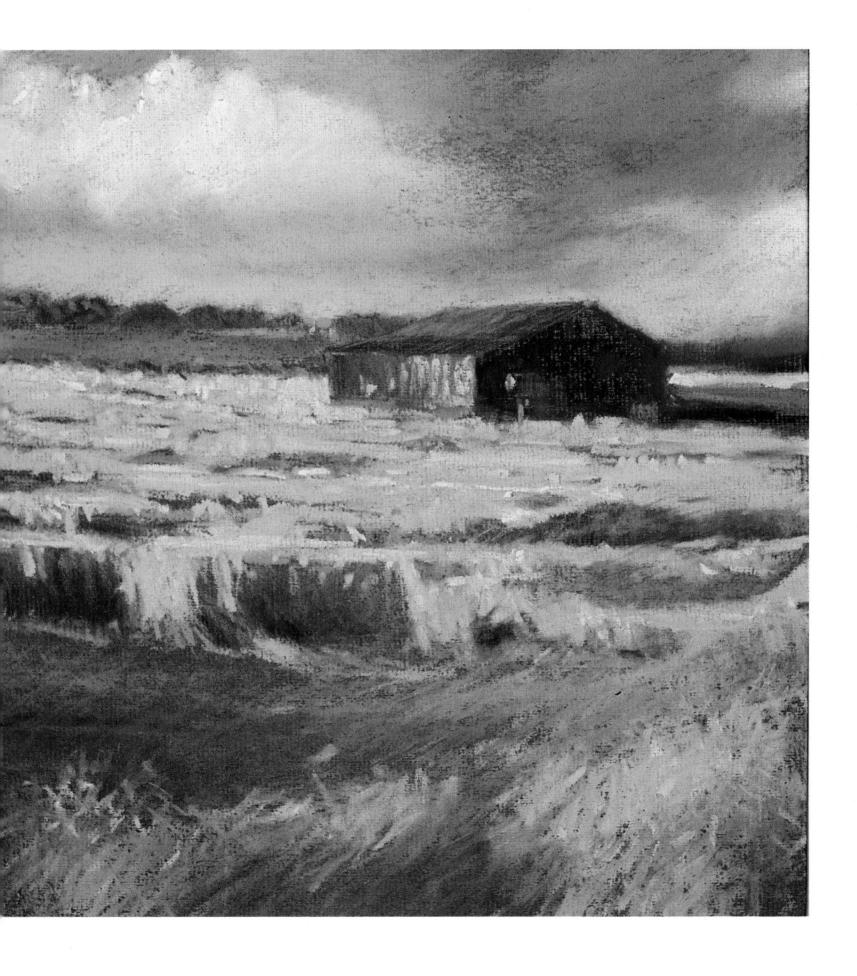

HOW DO I START?

One of the most exciting things about pastels is that the artist can exercise ingenuity to the full, and there are absolutely no rules. Some people prefer to start their painting with only the haziest idea of what it is to be about, while others prefer a detailed drawing. These drawings can be outline drawings only, or they can be finished drawings in their own right, with colour, and light and shade. The pastels can then be used to fill in the colour.

The colour of the paper used contributes much to the finished product, and pastels are unique in this respect. The paper colour is, in fact, another colour. Pastellists, especially portraitists, often leave part of the paper blank, with maybe two or three lines across it to suggest what would have happened had colour been used overall. This is not laziness; by

merely indicating, for example, the top of the dress or clothing, attention is not drawn away from the focal point of the picture, the portrait itself.

Before putting pastel to paper, it is worthwhile going through the various subjects of paintings, in descending order of suitability for pastel: Portrait and Figure, Still Life, Nature, Landscape, Abstract. Naturally all these subjects can be done with pastel. The kind of picture you are going to do is bound to influence in some way or other the kind of technique you are going to employ. Another important factor is whether you are doing a picture from life. with the subject before you, doing a picture from a photograph, postcard, or other illustration, or if you are doing a picture from imagination. Illustrations are often a good taking-off point, stimulating a memory, or suggesting a line of approach. There is something to be said for trying to copy a famous pastel painting from a colour photograph.

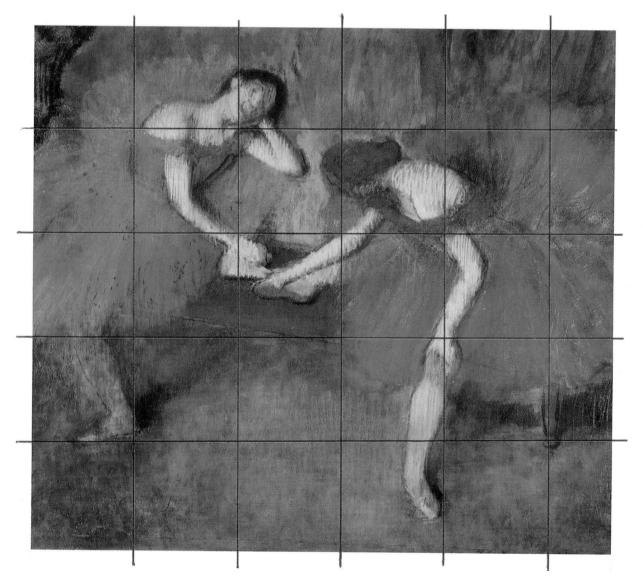

A good way of learning all about the use of pastel is to copy a master, as in the delightful *Two Dancers Resting* by Degas. It can be squared-up by drawing a grid on a photograph or print and using the lines as positional reference as in the exercise (far right).

The Very First Steps

Decide what kind of paper you are going to use. pin it or Scotch-tape it to a drawing board, or place it on a flat surface, with or without a pad of newspaper beneath the paper. Place your materials within easy reach - if you are righthanded keep the pastels by the right of the paper. It may seem obvious, but sometimes the obvious is overlooked. When the pastels are new, they have neat labels on transparent wraps; these labels soon go as the pastels become used, so it is no bad idea to keep the pastels on a labelled tray – a piece of corrugated paper is ideal. The sticks of pastel soon break anyway, so if it is more convenient break them beforehand into one-inch lengths. Pastels being used will soon get dusty, with specks of other colours adhering to them, but there are ways of cleaning them.

The best is to place the grubby pieces of pastel in ground rice, and to shake the container about. This simple operation will clean off the unwanted dust, which is absorbed by the rice. When the rice gets dirty, replace it. No matter how you use the pastels you will eventually have tiny fragments, too small to pick up with tweezers, which seem to be useless. Get all these odds and ends together and pound them with a mortar and pestle (household ones are not expensive). Having done this, add water, and let the mixture set. When this has occurred, cut the mixture into lengths, and you have new pastels, maybe an odd colour, but very useful. If you have a lot of bits, sort them into dark and light colours and make two different hues.

Beginning the Picture

The first marks do not have to be important. As suggested earlier, you can give the paper a few splashes of colour with a sponge or perhaps a soft brush. You may care to develop this in watercolour if the first signs are promising. If you have a definite object before you, then you may wish to put down your first impressions in charcoal, which rubs out easily with an eraser or the finger tip. It can be held like a pencil, or loosely by the far end. Do not press too hard or it will snap.

If you are painting with a subject in front of you, the still life can be most satisfying. Ordinary kitchen equipment is a good starter, maybe combined with a loaf of bread and some china. There is nothing better than an assortment of fruit as a still-life subject – far easier to paint, in any medium, than flowers.

There is always a temptation to draw in outline, but remember that a line does not exist in nature – it is merely the edge of a shape. So if you can think in shapes rather than outlines it is a big advance; and shapes are easier to do

Another interesting way of finding out the properties of pastels is to use simple shapes, like French curves. The student has made an intriguing abstract design by tracing round them in two different positions. One can then explore the different idioms of pastel.

than outlines. Of course, you need to define the edges of the shapes, but a good way to get the shape down is to use the *side* of a piece of charcoal, so you are working with a flat piece.

These first marks can be tentative, as you try to get the feel of it. They can be squiggles, they can be lines exploring the way the shapes go, they can be little blotches setting down the shadows. No matter what medium you are working in, remember that light and shade are vitally important, far more important than colour in making a picture which is 'like'. It is a good idea when setting up a still life (or for that matter when doing a figure painting or a portrait) to have strong light coming in from one source (easier from the sides, more difficult from the front, more difficult still from the back). Light and shade define the forms or shapes.

It cannot be stressed too often that the way you work is determined by you and you alone. If you feel that you want to put in the outlines first, and fill in from there, go ahead.

Your preliminary sketches may seem meaningless to everyone except you, but you may know exactly what is going to come out. The main object should be to get the articles you are painting coming together on the paper as a coherent group, not odd things scattered around by themselves. This is more important than accuracy; no one is going to award you a prize if the bump on an apple is absolutely right or if the curve of a banana is too pronounced. Unless your aim is to be purely decorative, try to get the feeling of the solidity of the objects you are painting. You do this simply by finding out where the light is falling, and darkening those areas which are shadowed.

There are two kinds of shadows. There is the shadow which occurs away from the light, and there is cast shadow, in which an object already in the shade throws a shadow over something else. Cast shadows are darker than ordinary shadows. Ignoring light and shade is the reason why so many amateurs' pictures in all mediums are flat, no matter how well they are coloured.

The preliminaries can naturally be done in pastel without the use of charcoal. It is best to use a neutral colour, though tempting to use black (neutral means a colour such as muted brown or grey). Black pastel is far more substantial a colour than charcoal, and not so easy to remove. Although pastels are opaque, some colours are more opaque than others. Again, however, it is a matter of personal choice, as you can build up a pastel picture layer upon layer until even the blackest underpainting is hidden. When you are using pastel for the preliminary sketch you can also use it on its side to give areas of colour rather than strokes.

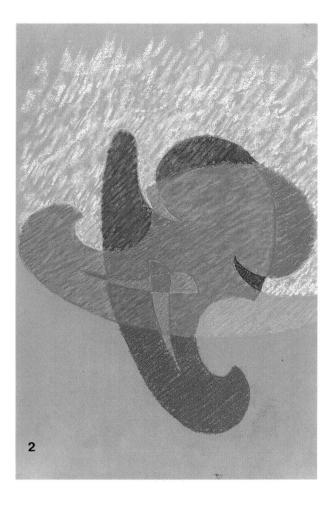

- 1. A pointillist effect has been achieved by the careful blending of colours.
- 2. A sense of atmosphere can be carefully captured by using a limited range of colours, in this case greens, to give a cold effect.
- 3. As in *I*, colour has been built up by using two or three different pastels to create the overall colour.
- 4. A studious approach to colour selection can produce an advanced abstract painting.

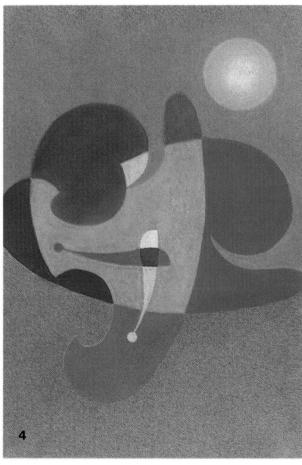

Applying the Pastel

The natural way to use pastel is to hold the stick like a pencil and using the end to colour the paper. Held at a slant, the pastel will give a thin line; held upright, a thicker line. Held lightly, the pastel will deposit less colour on the paper, and the colour of the paper will show through. Sometimes the colour of the paper can be the background without anything more needing to be done to it.

There are numerous ways to apply the pastel. Short stabs of colour can be put down, giving a patchwork effect. Various colours can be set side by side in thin strips, or 'cross-hatching' can be used — making a network of strokes, like a crossword, either the same colour or different colours. Dots of colour can be used, areas of colour can be laid down by using the pastel on its side, applied thickly by pressing down, or thinly by a lighter touch. All these techniques can be combined.

It is best to experiment with these methods when painting a picture than to do meaningless exercises on a piece of paper. A picture of some sort will emerge – it may not be much but in all art the painter gets better. A technique acquired is a permanent acquisition.

Unlike watercolours and oils, pastel colours are not mixed or blended beforehand but are mingled on the paper, using contrasting dots or patches of colour, cross-hatching, or, the favourite way and the one most used by the great pastel painters of the past, blending the colours together with the finger-tip a stump or torchon, tissue, a cotton-bud, or a brush. Some art teachers frown on finger-blending, as they say it destroys the 'bloom' of pastel.

What is this bloom? It is the effect arising from the reflection of light on the tiny granules of pigment. It can be destroyed by too much rubbing, but the remedy is to apply more pastel after the colours have been suitably blended. You have to use some discretion when finger-blending, for it is easy to make a muddy mess when too many colours merge.

Sometimes the immense variety of the tints available encourages colour mess, and if there is a risk of being overwhelmed by the sheer quantity of colour it is not a bad idea to try using a limited range of black, white, and some intermediate greys (green-grey, blue-grey, etc.).

Finger-blending can produce a perfectly even colour surface, to which shading can be added by a few granules of darker colour. This does not have to be black. Sometimes a subtle shading is wanted, where the light area merges into a darker, as around an apple or orange. The colour can then be a darker tint of the same colour, or maybe a blue.

In the early stages of painting a pastel, the

subject can be gently covered with a light single colour, to set the tone of the picture, and the shadows set out on this, with a touch of white to pick out the lightest parts. The 'real' colour can then be added. It is a matter of choice whether you do the picture bit by bit or tackle the whole picture in stages, so that it all comes together at the end. If you think that the picture is becoming flat and boring, you can enliven the textures, either by using pastel in a different way or roughing up the surface with a dry bristle brush. The 'highlights', those vivid small patches of white which can make a picture live, should be reserved to the very end.

At some stage in a picture you will look at the blunt end of a worn-down pastel and wonder how you are going to get any kind of detail. This problem will occur particularly in portrait painting and landscape. Do you break off a short length of pastel so that you have another sharp edge? Do you grind the blunt end down with sandpaper? You can waste a lot of pastel, and in fact a worn stick of pastel is clumsy, so that you have to resort to smaller fragments, too small to hold in the fingers. The answer is to hold a fragment of pastel with a pair of eyebrow tweezers, and use this to get fine detail, or make use of a pastel pencil. But do not expect pastels to give you the degree of precision you would get with watercolours or oils. Nor can you expect the kind of coverage you get from oils. On the other hand, it is very easy to be impressionistic or 'suggestive' with pastels, and once you are experienced it is the ideal medium for extremely quick on-the-spot sketches - you can cover a sheet of paper in two seconds flat.

One of the great advantages of pastel is that correction can be carried out quickly and decisively, either by applying a further coat of pastel or by removing some, either with a putty rubber or the dry bristle brush. It is also easy to correct or transform tones, and alter any shapes, very important in portraiture where the proportions *must* be right. An excellent way to check accuracy is to hold a work-in-progress up to a mirror, where any faults will stand out immediately. The speed with which you can work with pastel is a real asset when it comes to painting portraits; still life and landscape do not move. People, with the best will in the world, do.

There is always a temptation in pastel to make the colours too bright and, it must be said, insipid. If a picture is turning out tamely, a remedy is to mute *all* the pure colours with a neutral tint and add more colour very sparsely. If the greens of a landscape are too garish, blend in greys or some red. There is also a temptation to be satisfied with pastels that are

A simplified pastel technique can effectively suggest trees or foliage in contrast to that used by Degas in *Dancers Preparing* for an Audition.

over-bright; pastels can be rich and subdued, as the great masters of the 18th century have shown.

With the possibilities of instant art, the ability to get an immediate effect without any kind of preliminaries, there is a temptation to apply pastel without prior thought. Without any need for preparation, the appeal of the various coloured papers, which look so agreeable in the pads of mixed colours, is often irresistible. So colours are put down; a picture is completed: from a distance it may look all right, even impressive. But perhaps it is merely flashy. Perhaps the artist can mute the garish colours, but should they have been garish to start with? And is the blaze of colour just that, colour without drawing or tone? Look at the pastel work by the great masters such as Degas and Manet. There was preparation here, as much preparation as these artists put into an oil painting. They were not interested in an immediate effect, they were not bemused by the easiness of it all, and there is no doubt that the act of putting a pastel to paper is the simplest of all actions, whether it is a child playing with its first box of wax crayons or the newcomer to pastels finding that an impression of the sea can be obtained in five seconds by drawing a flat length of dark blue pastel horizontally across a piece of light blue paper.

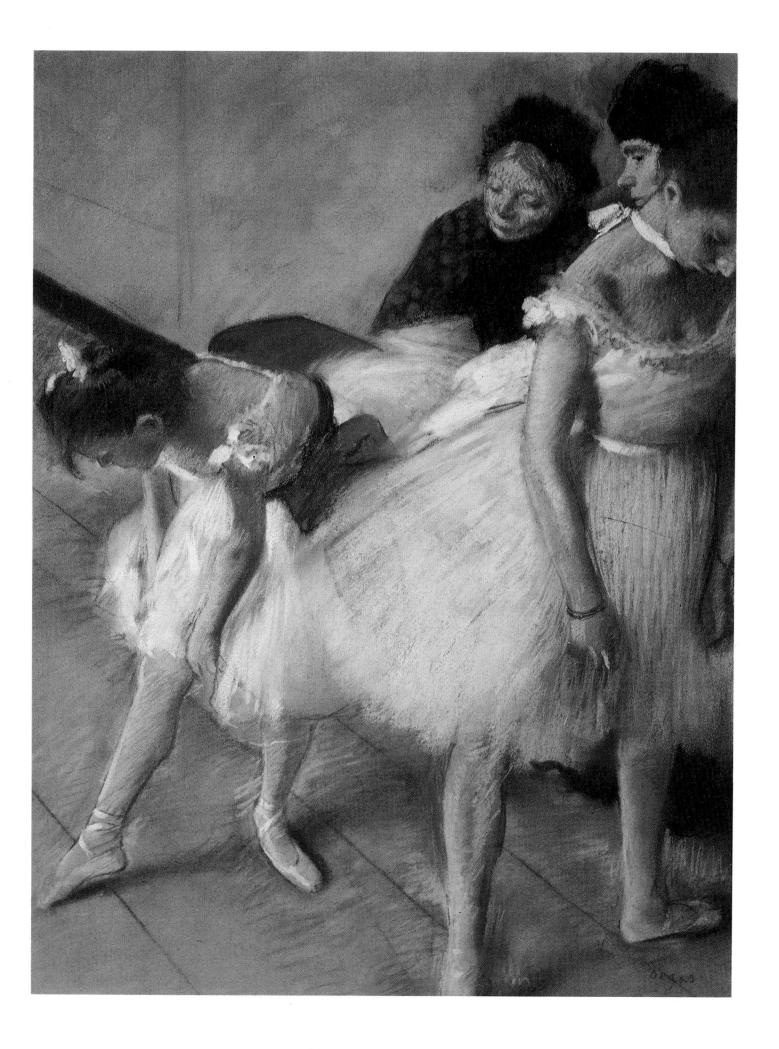

Eight drawings of apples, each one having a different tonal background to enhance the colour. It is worth noting that the drawings in which the colours are most enhanced are those where the backgrounds are dark. This demonstrates the luminosity which can be achieved by using dark coloured papers.

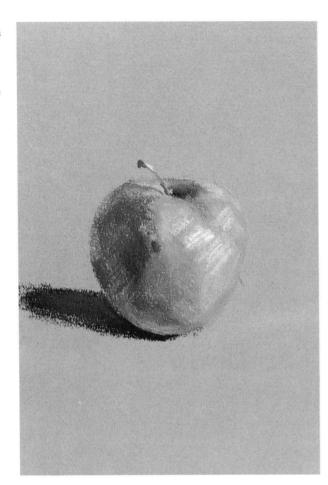

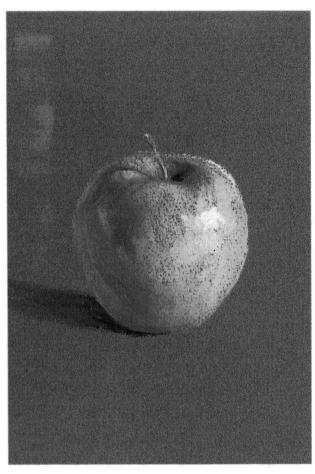

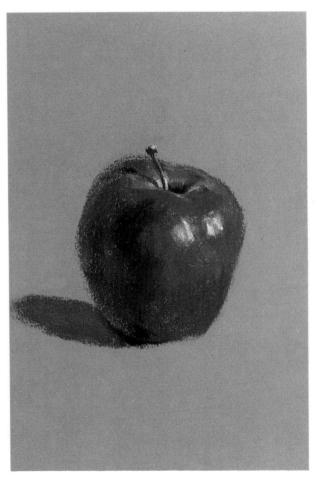

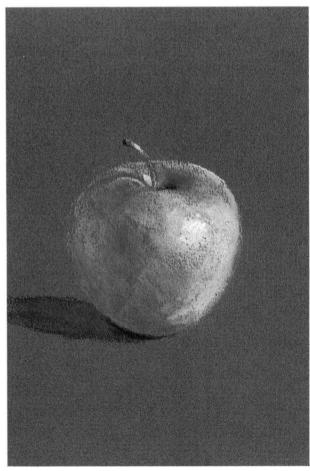

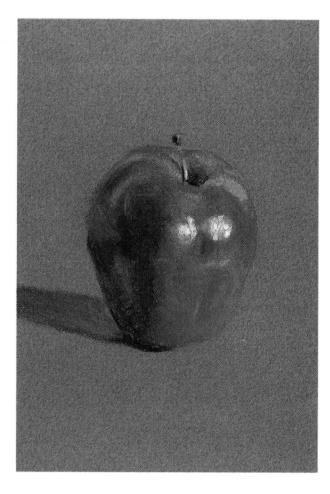

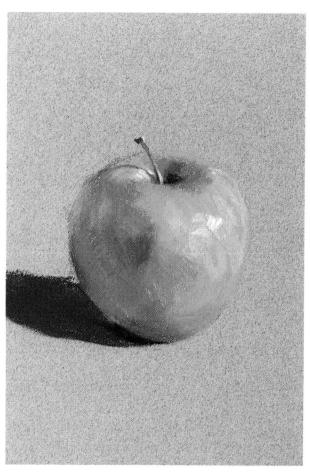

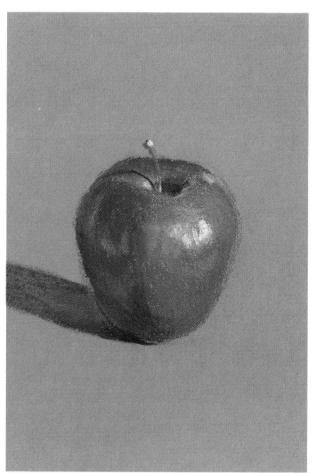

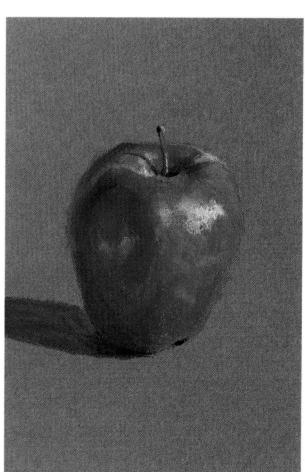

Drawing with Pastels

The first thing is to choose the right tint of paper for the picture you have in mind. This can be a very personal choice; it may not be everybody's. You have to visualize what sort of impact certain colours will have on certain backgrounds. If the paper is very light, a lot of work will need to be done with dark pastels; if the paper is very dark, you will be busy with the light pastels. This may be what you want, but if you are undecided it is perhaps better to choose a paper halfway between black and white. It is possible that you have a landscape in mind, perhaps a sunset, in which case a pink paper may prove the appropriate one; the pink can be used, it does not have to use the artist.

Unless you are just interested in creating a flat pattern or a picture with the various elements running parallel with the picture surface - in other words nothing recedes and nothing is placed in space - it is necessary to know something about perspective and simple drawing. Neither is difficult. Much of it is common sense. The amount of preliminary drawing that goes into a pastel is determined by the artist; there may be very preliminary scribbles in charcoal or pencil to indicate the approximate placing of the elements in the picture, perhaps a few vertical and horizontal strokes to determine proportions. If you want a realistic picture it is important to draw what is there not what you think is there. And remember that although you will use outlines, an outline does not really exist 'out there'. It is a convention. You are drawing three-dimensional objects in two dimensions.

What is an outline? Nothing more than a dividing line between areas which are light and areas which are darker. Successful drawing, whether with a pencil, a paint brush, or pastels, depends on looking and assessing, seeing how some shapes relate to other shapes, and how light they are regarding each other. The shapes can be simple or they can be complex, but all can be put down in a convincing manner. A good example of a simple shape is a single apple on the table. We are not interested in how it grows, what the arrangement of the pips is inside, or how it tastes. We are more concerned with its solidity, and how it sits there. The look of the apple is determined by the light shining on it; away from the light the apple will be darker, and this darkness becomes less as the light area is approached. The apple will throw a shadow, and the shadow - the cast shadow - will be darker than the shadows on the apple or the background shadows.

Where the lighting is very stark and dramatic you may not be able to detect the shape of the

apple at all. All you may see is a bright curve where the light strikes the side of the apple, with the rest of it in darkness. You will know what the apple looks like even if you cannot see it in full light. The same applies to another simple shape, a cottage in a field. We do not need to know how the cottage was built or how many rooms there are inside; all we see is a rectangle with a shape on top, the roof. Depending on where we are standing we may see part of the side of the cottage, and the shadows will depend on whereabouts the sun is. The rectangle will be broken up by inner rectangles – the doors and the windows – and we know they are there because we know about buildings and are interpreting what we see. If the front of the cottage is in part shadow, a window may show up as a small horizontal slash of light where the sun picks out the window sill. A door which a child would portray as a tall rectangle (with maybe a blob for the door knob) may be recognized by a dark shadow part-way up the cottage, where the upper part of the door, partly inset, is overshadowed by the brick work

The cottage may be built of brick, and some of these bricks, depending on the light, may show up more than others. So although you will know the bricks are there, and you may be tempted to begin putting them all in, you will not be able to pick them all out if you are standing some distance away from the cottage. You will just see changes of tone and, if the bricks are old and handmade, some changes of colour. If the lighting is from above, if the sun is high in the sky, the bricks may merely be detected by shadows beneath them (bricks slightly protruding casting their shadows on to the bricks below or the mortar).

The effect of solidity is achieved by placing an object in space, space of your own making, and this is done by using perspective. Perspective is with us all the time, and we take it for granted. If you lift your eyes from this page and look around at any angular surface such as the top of a chest-of-drawers you will see that the top does not appear to be a perfect rectangle, and that the two sides almost imperceptibly seem to move towards each other. If the chest-of-drawers was 200 metres long the sides would most probably appear to meet. If the top of the chest-of-drawers is just below eye-level the angle of the top will be sharper than if you are standing up and looking down on it. Perhaps perspective is more readily appreciated by going outdoors.

If you look along a straight road towards the horizon the road appears to narrow, and a person travelling up this road seems to become smaller, losing height at the same rate as the

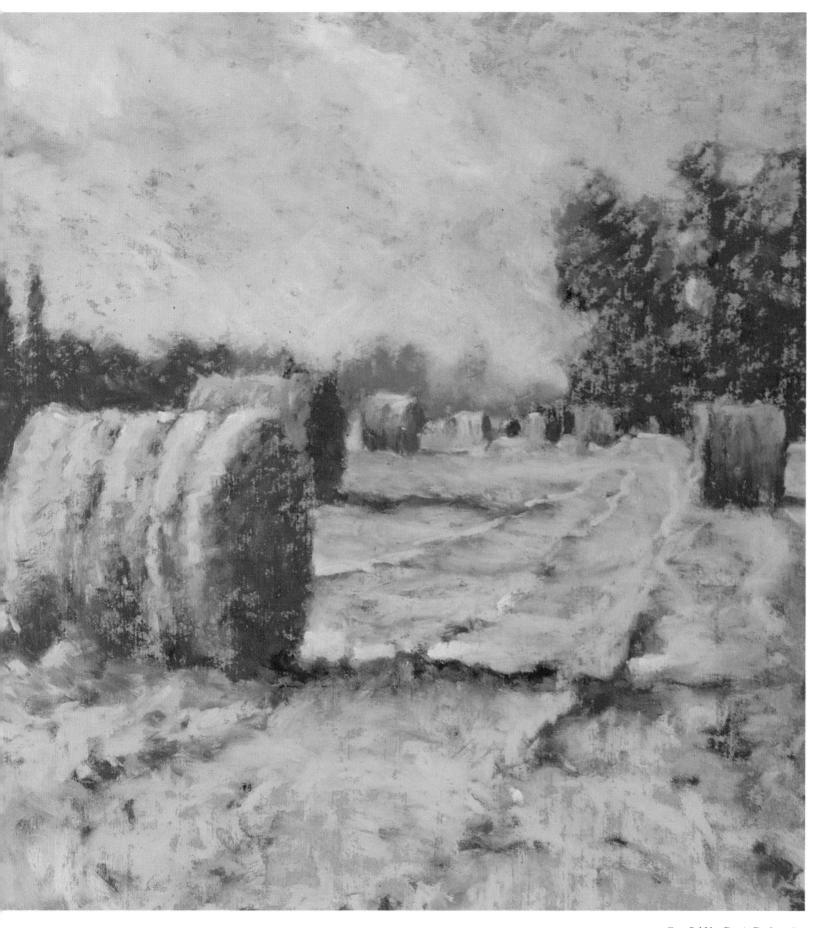

Cornfield by Denis Barker. An atmospheric study of harvest time.

Detail above: Sharpened pastel has been carefully used to show tree details.

Detail right: The detail shows pastel technique

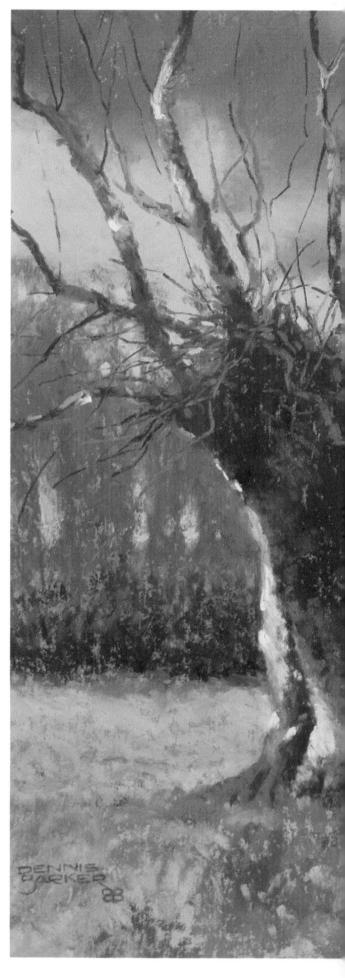

Water Meadows by Denis Barker. This interesting composition is enlivened by the dramatic winter light.

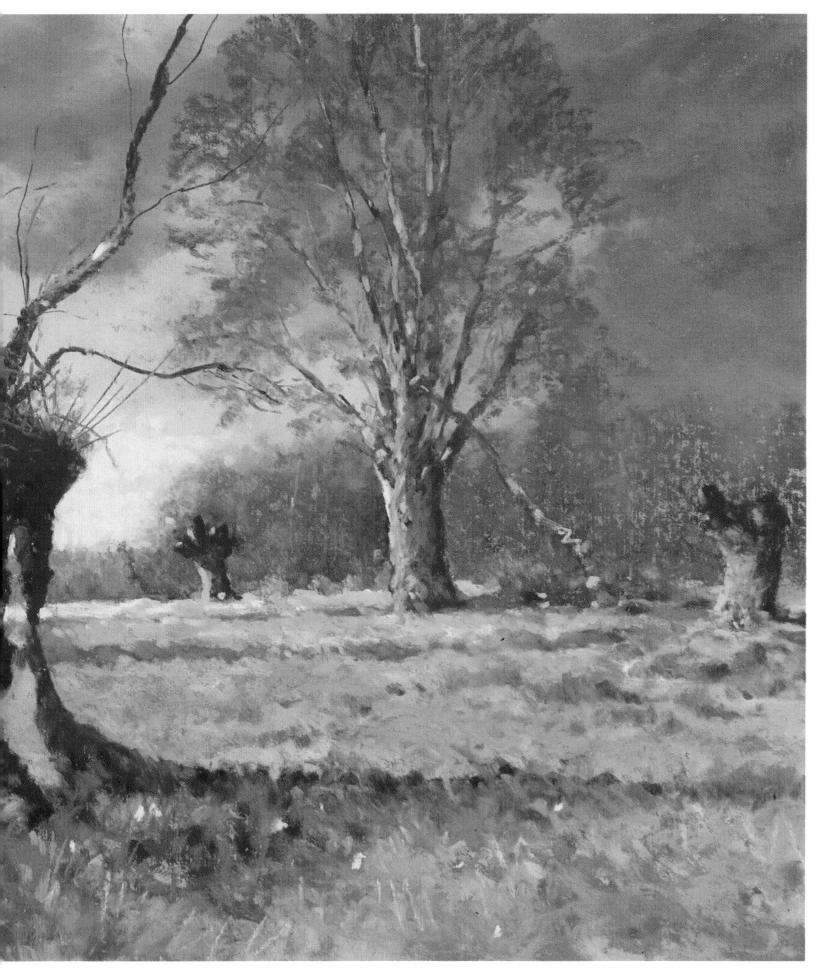

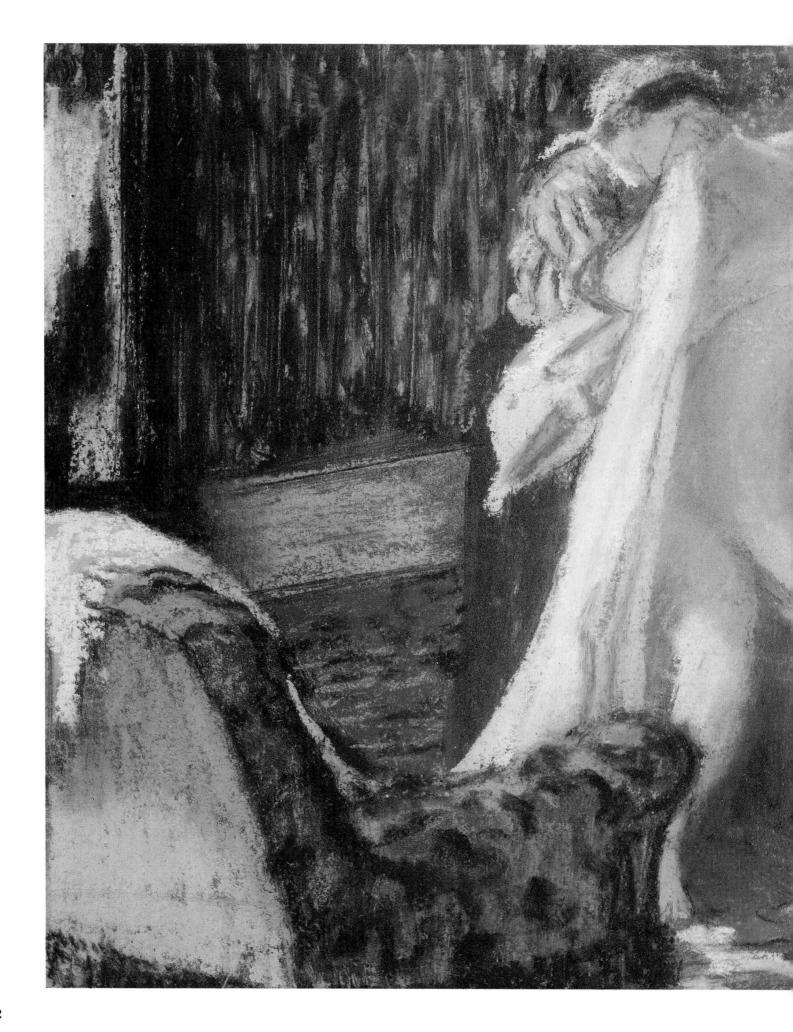

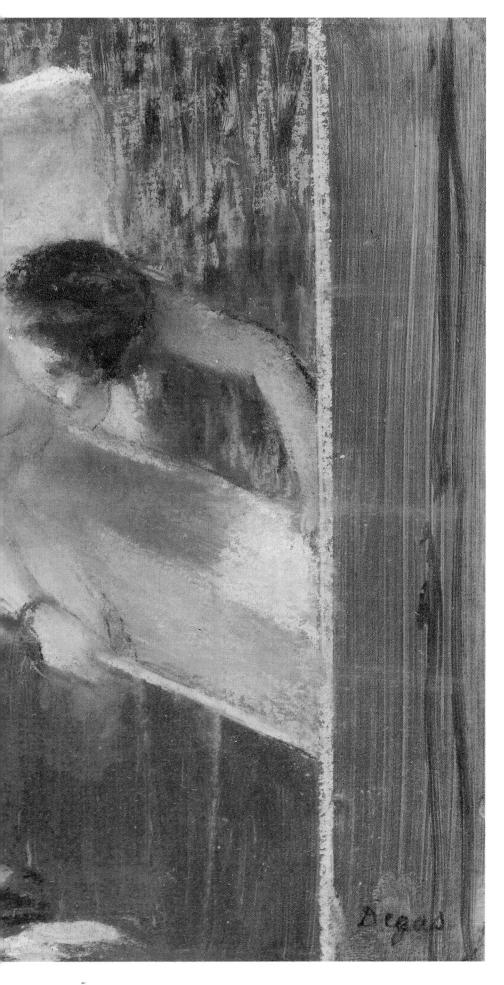

road narrows. Telegraph poles will seem to shrink in proportion, and if you draw an imaginary line which connects the bases of the poles and another which connects the tops of the poles and extend them you will find that they meet on the horizon. The only time to see a true horizon is at sea where sky meets water. The horizon has nothing to do with the sky-line. If you are in mountainous country the sky-line is way above you and the horizon is behind the hills and mountains at eye-level. For that is where the horizon is, always at eye-level.

Objects above or partly above eye-level seem to go down towards the horizon and those below seem to go up. If you stand at the top of a high-rise building and study the pattern of roofs you will see them all converging towards the distance, where the horizon is. They will not always be converging towards the same place on the horizon, for although there is only one horizon at one time, and in any one picture, there can be several vanishing points. If you go outside and look at the roof of a house you will see it obeying the laws of perspective. It will point towards its own vanishing point. If it is a terrace of houses of the same size and kind their roofs will all recede to the same point, unless they are in a crescent. But in a traditional old-world village with houses and cottages built anywhere, each roof (and each wall) will have its own vanishing point.

The horizon can be as high or as low as you wish, and can even be off the top of the paper if you are looking down on a subject. But it is there. Sometimes perspective can be tampered

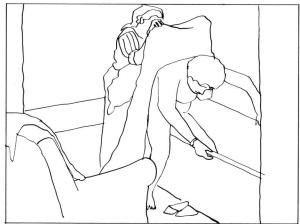

This small pastel study by Degas is brought to life by the clever use of perspective. The lines of convergence would, interestingly, meet behind the figure. Woman Getting Out of her Bath.

with to get an effect, and perspective can be fun. The painters of fantasy pictures sometimes use two perspectives in the same picture to achieve a kind of unreality. Perspective is a tool of the artist; it does not have to be exact; that can be left to architects.

One of the obvious facts about perspective is that objects 'in the front' of the picture are much larger than those behind. A way to illustrate this is not in drawings but in photography. If you photograph a figure in bathing costume on a beach, a favourite subject, and the legs are extended towards the camera, these legs can appear ridiculously long and malformed. When we are looking without a camera we make mental adjustments; the legs are so long, and that is the end of it. But the camera does not make such adjustments. It records. If a person extends a clenched fist towards you it appears enormous, and can appear larger than the rest of the person. This 'device' is much used in advertising and in posters.

Some of the least obvious subjects are governed by perspective. Failing to take account of it can result in pictures being flat and uninteresting, white blobs against the sky. Clouds are objects in space, just as everything else is.

Perspective is not so much a law as a convenience; it is certainly not a hard-and-fast law like the law of gravity, because there is an exception which goes under the name of accidental vanishing points. Surfaces which are tilted sometimes — and the key word is sometimes — converge on vanishing points which are above and below eye-level. The best way to illustrate this is to hold a sheet of card at a slant. A good example is to look at a road going uphill where the sides will appear to converge at a point above the horizon; below the horizon if the road is going downhill. This of course is useful if you want to depict a road going uphill or downhill from memory.

A working knowledge of perspective is a help if you are inserting extra features into a 'real' landscape. If it is a person you work out how tall he or she would be in the foreground, perhaps getting the dimensions by reference to a tree or a door in a building. You then draw perspective lines to the horizon from the top of the figure and the bottom, and you use these as a reference to fit in the extra characters wherever you like. They do not have to be within the lines of course. They do not have to look as though they are waiting in a queue. You can set them anywhere parallel with their projected position.

A student's drawing showing a perspective exercise.

Aerial perspective has nothing to do with the kind of perspective we have been looking at. It is all about atmosphere. Dust and moisture obscure more distant objects, and the further away something is the lighter in tone and the less distinct it will appear. In pastel this can be indicated by lighter colours, a broken line, absence of detail, and the use of bluish tints, perhaps overlying the 'local' colours by using the flat of the pastel very lightly, just brushing the paper surface. Detail in the distance can be blurred by gently going over the pastel with the tip of a finger, a stump, or a cotton bud.

Does perspective work for you? The easiest way to find out is to go out and sketch a building, where perspective can most easily be seen in action. How do you start? First put in a horizon. If you have difficulty deciding where this is, extend your fist with the thumb uppermost until it is on the level with the eye. This is your horizon. If you stoop, the horizon will change. You can then put in preliminary casual lines, perhaps in charcoal or a neutral tint such as mid-grey, not worrying if they are accurate but setting the scene. As you become more certain you can press a little harder on the charcoal or pastel, finding a good starting-off point, maybe an angle of the wall where there are sharp, easily depicted shadows, perhaps a window or window surround. Concentrate on the parts which are most interesting; maybe an elaborate doorway, with interesting shadows inside. There is no need to go on to complete the drawing.

Cottage and Stream, an exquisite pastel by Ken Jackson, uses advanced perspective techniques.

Landscape and Townscape

Landscape is unquestionably the most popular form of art amongst non-professionals. It always has been and always will be. And it is equally suitable for pencil, pen-and-ink, watercolour, oil, acrylic, and pastels. The reasons are many: landscape is there and does not have to be arranged; you can pick the vantage point that suits you, avoiding difficult subjects if you wish: landscapes are motionless, and although there will be changes of light they proceed mostly at a leisurely pace. And doing a landscape on the spot can be an enjoyable day out. Pastels are very convenient for outdoor work as there is no water to spill, you do not have to wait until the paper is dry before carrying on, and if there are sudden climatic changes you can take advantage of them simply by virtue of the speed with which you can put something down on paper. The main thing to remember is to keep your pastels in a secure box or tray so that they do not roll or get blown away. Always take a variety of different colour pastel papers with you, and use the appropriate colour for the weather conditions. If the weather is brooding and it is all set for a storm, use a grey. If it is brilliant sunshine, and there are promising cornfields, use a yellowish tint which will give a sunny feel to the picture and can also be used to depict the cornfields without much added pastel (except to add tone and shadow).

Only depict what you personally find interesting. If you find the view dull you will produce a dull picture. It is never much fun to do things for practice; you are not being paid after all. Some advisers recommend pastel-users to do little squares of colour to see what they look like. But you know what the colours look like. If you miscalculate, what does it matter? Trial and error will teach you more than a series of little squares of pastel colour.

When you are looking at a landscape you may wonder where the 'edges' of your picture should be, and where you should start off. Where should the picture begin and end? An easy way out is to make a home-made viewfinder, a piece of card with a rectangular hole in it which you hold against a likely view, either horizontally or vertically. Not only will you be able to pick a good composition (in which the interest is held in the picture rather than drifting out the sides) but it will help to relate the elements to each other, working out which shapes are darker than others, when halfclosing the eyes helps. When you start, it is better to start at the focal point of the composition (a barn, a tree, a stream) and work outwards rather than start at the left of the picture and fill in methodically across the paper (or right to left if you are left-handed).

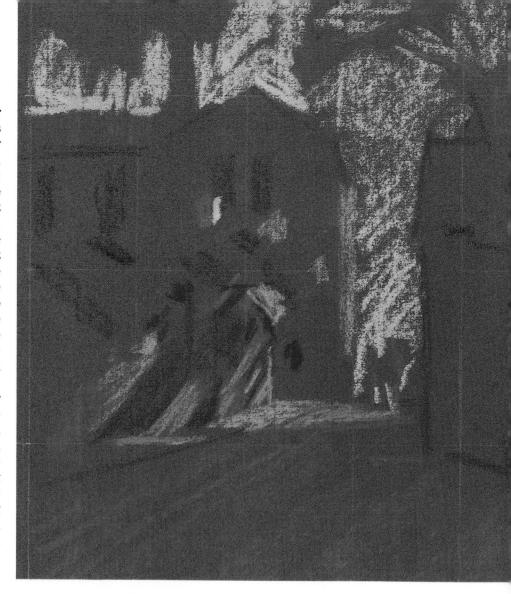

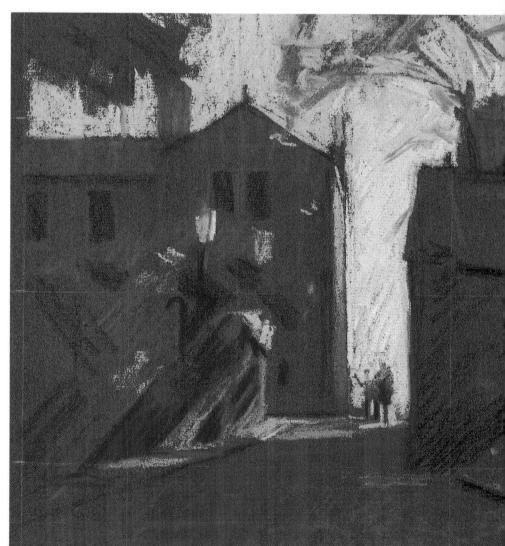

Left, above: The first step in the making of the pastel overleaf. The artist has quickly sketched in the basic shapes, using the sky for definition.

Left, below: The atmosphere of the picture is beginning to come alive through the dramatic use of light and shade.

If you are doing a realistic pastel, put down what you can see, not what you know is there. If there is detail it is in the foreground only (you are not a predatory bird which can see a mouse at 200 metres). If there are trees look how the shadows fall, how groups of leaves throw shadows on those below, and those below that, and discover that you cannot really see the individual leaves in a cluster but only varying tones. What might seem changes of colour may be changes of tone.

Trunks should be made to appear solid, by shading, and varying the degree of shading to indicate roundness. Try not to put in a symbol of a tree, rather than a real tree, and trees by themselves often have trunks which are not absolutely vertical. Do not forget the shadows beneath the tree, which may well prevent the trunk being seen, and study how the trunk goes into the ground and does not stick up on top of it. When doing a landscape, all the objects are in it, not on it. Individual blades of grass are in the foreground, not the middle distance, and in pastel they can be expressed by putting in a background colour and adding discreet strokes, remembering that even individual blades of grass have their shaded side. Except in the foreground, grass can best be expressed by shading. Tufts have a shaded side and cast shadows onto the ground just as something more solid, such as a boulder, does. In the middle distance grass is best represented by graduating the tones as the ground rises and falls.

Bushes should be observed very closely, for the changes of tone need not be dramatic, and there is nothing easier than making a bush look like a crumpled dishcloth. Half close the eyes, and try to get the feel of 'bushiness', observing how the clumps of leaves near the top of the bush throw shadows on those below, and how the bottom of the bush, often in deep shadow, can be enlivened by foreground grass and plants which are in the light and therefore silhouette themselves against the shadow. Hedgerows are marvellous props in the distance, helping to define fields and establishing relative sizes of other objects, such as far-off buildings.

Much that applies to landscapes applies to townscape. Never anticipate detail which you cannot see; always place in the horizon at an early stage, and use perspective lines as a help in drawing objects to scale. Of course there are more pure verticals in townscape, easy to put in with lightly applied pastel on its side (what the verticals represent can be added later). If you are nervous about venturing into town armed only with a pad of paper do your work from your car. This helps, too, if you are embarrassed by people looking over your shoulder. Townscapes can sometimes look odd without people,

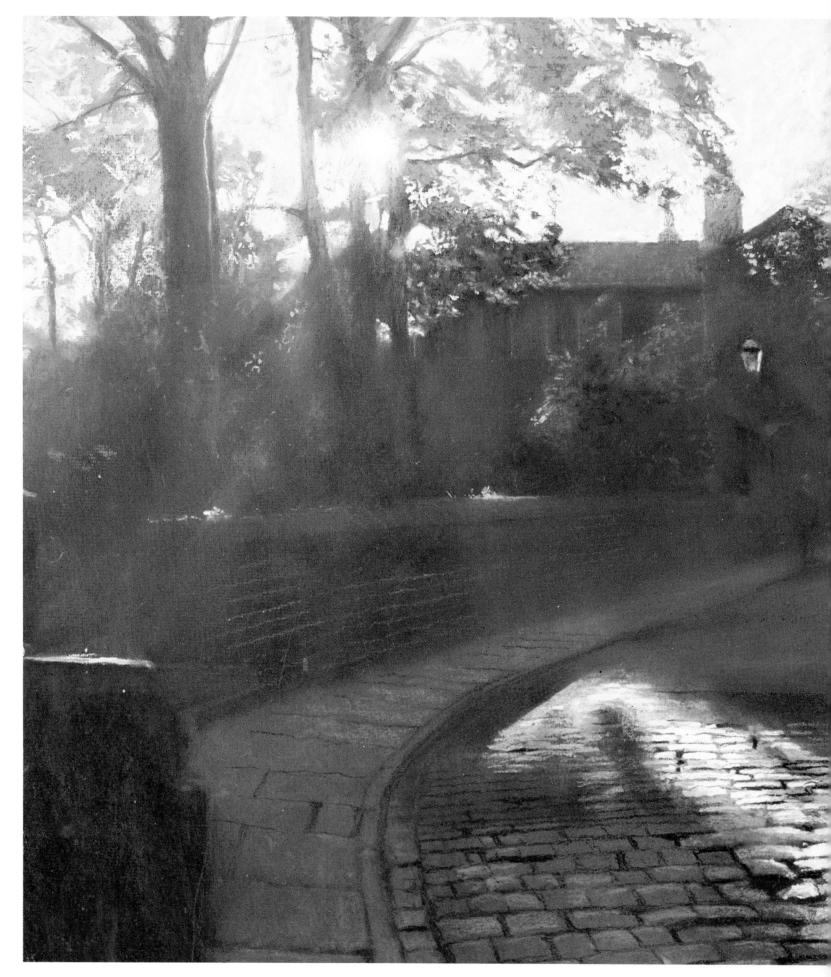

The finished painting. A limited range of colours has enhanced the dramatic quality.

so add them in. There is no need to do more than indicate them with a stab of the pastel, perhaps adding a little light pastel on the top to indicate the presence of a face. Use perspective lines to establish their relative size, and remember the shadows and that they fall the same way as other objects in the picture. It is also worth noting that groups of figures appear in a blob with smaller blobs (the heads) on top and that legs may not be seen if the light source is high.

Cars and other vehicles also contribute to the liveliness of a townscape. They can be indicated roughly, and act as focal points to direct the attention towards a certain part of the picture. If you do a car from memory you may get it wrong, overemphasizing the top and making the car too high. In a street scene the heads of the pedestrians are over the tops of the cars. You may make the windows clear, where in certain lights they may be opaque. The wheels may be almost completely in shadow, which may be a plus as you can suggest the curvature of wheels rather than patiently put in arcs (use the side of a coin if you cannot do curves freehand).

If you find pastel too broad for intricate landscapes and townscapes use sharper tools for detail – coloured pencil, pastel pencils, felt pens, and if the pastel surface is thick and fluffy go over it with an aerosol fixative which gives a crisp surface to further work, whether in pastel or some other medium.

Barn in a Field by Denis Barker: All the drama of aerial perspective and linear perspective are brought to bear in this atmospheric pastel painting.

Detail above: Note how the artist has used the reflected sunlight on top of the telegraph poles to reverse what would normally be dark against light as distinct from light against dark at the bottom of the poles.

As a general rule, as in this picture, warm colours suggest nearness and cold colours distance. The artist has managed to bring the picture to life by the suggestion of the yellow roof which is reflected light from the wheatfields.

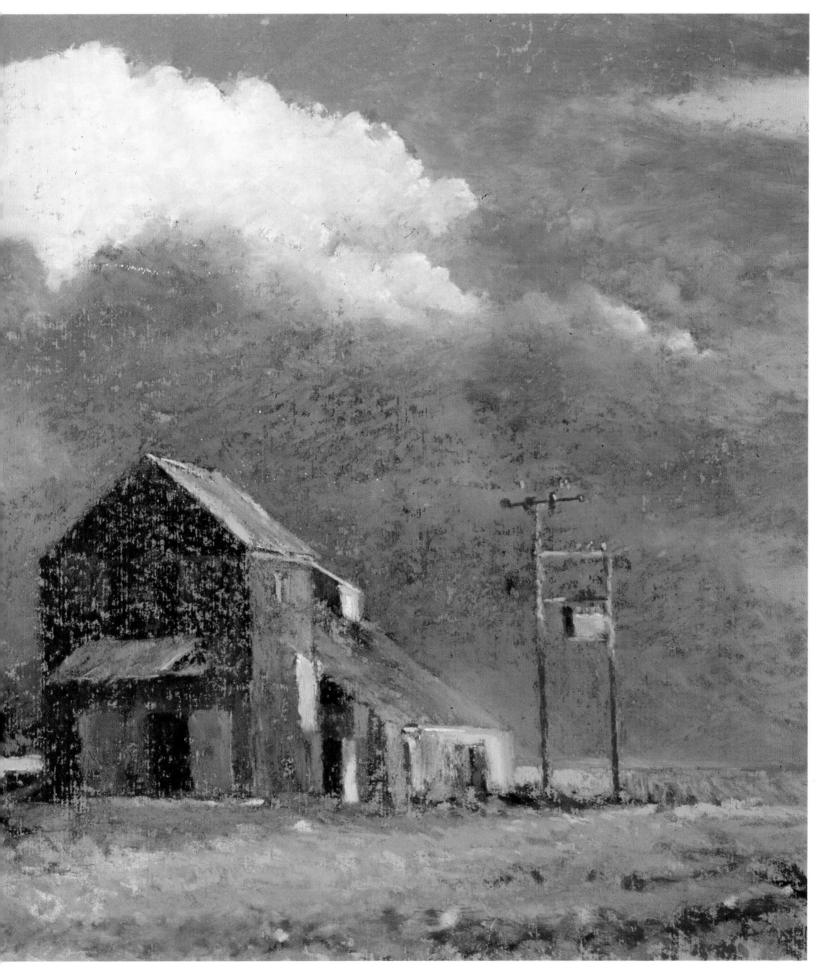

In this sequence of illustrations we show how easy it is to make a picture which uses the simplest design.

Step 1: The artist has chosen a blue-grey background and with soft pencil has drawn in his rough composition.

Step 2: With a broad rendering of the basic colours the picture has already established itself.

Step 3: Vigorous use of pastel has been applied to give more contrast.

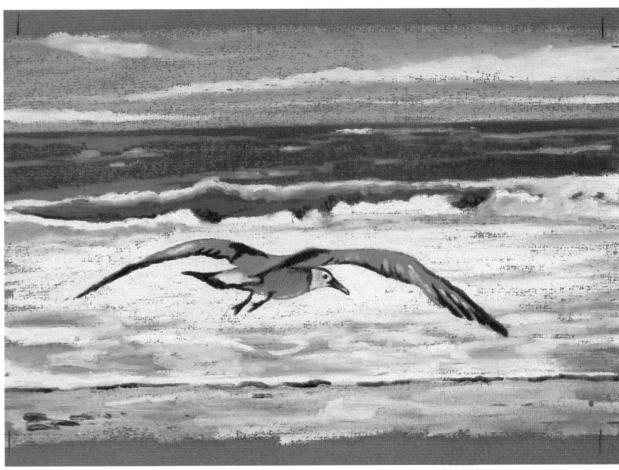

Step 4: The finished picture. (One thing a student of pastels must learn is to know when a picture is finished. Many a painting has been ruined by an attempt to render too much detail. One could argue that Step 3 is in fact a better picture than Step 4.)

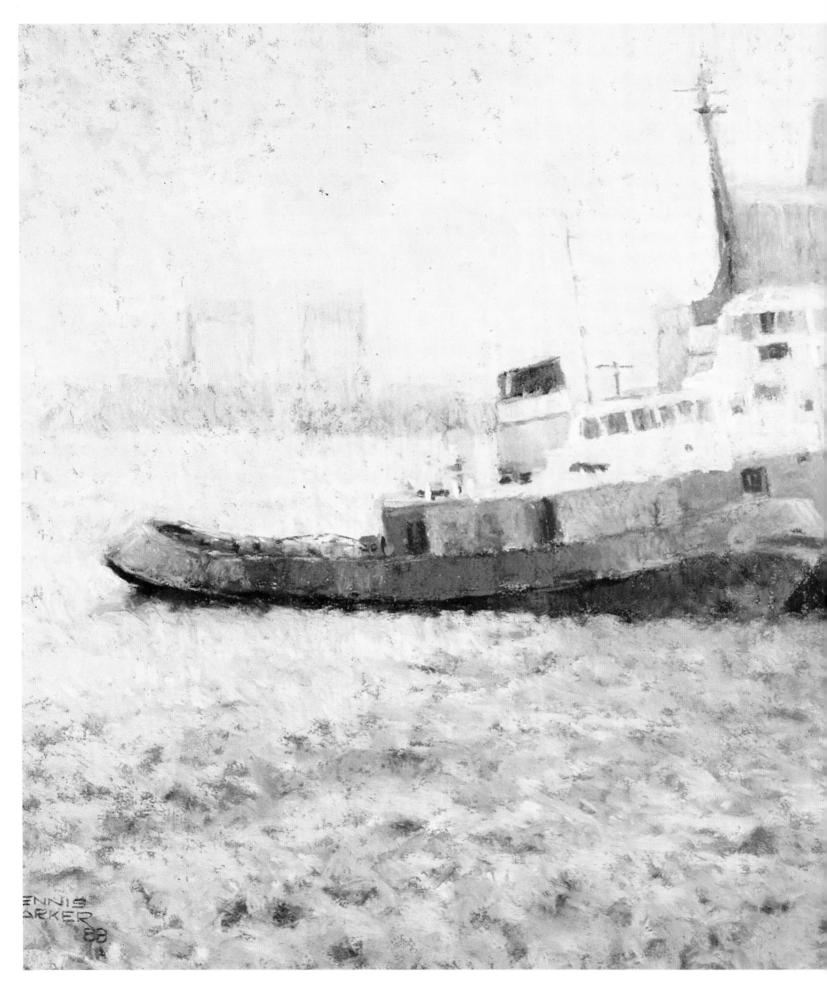

Tugs on the River by Denis Barker. The artist uses a broad technique to capture the atmospheric quality of the scene.

Left: A good example of aerial perspective. A painting in which a coarse technique has been used.

Lupins in the Landscape by Denis Barker. This charming landscape has been brought to life by the intelligent use of colour in the shadow detail which gives an Impressionistic quality of light. The lupins in the foreground hold your eye as the warmth of the flower causes the landscape to recede.

(a) Below: The clever use of aerial perspective is shown in this detail.

(b) Bottom: The whole picture has the feeling of moving to the left, thus uncovering the delightful rabbits which are brought to our attention.

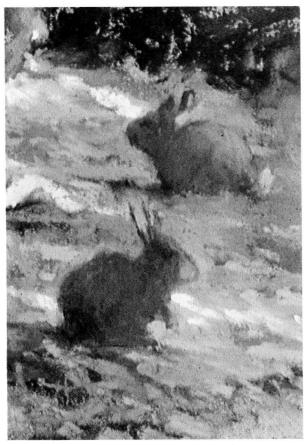

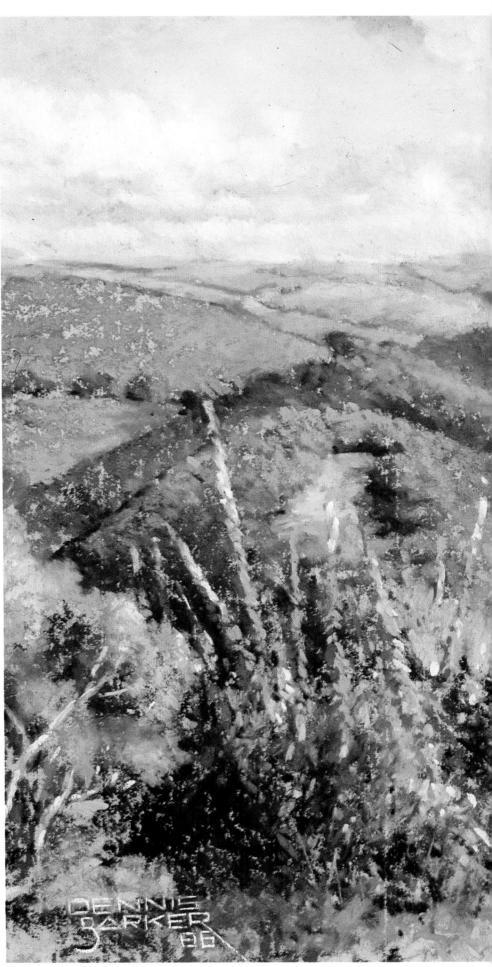

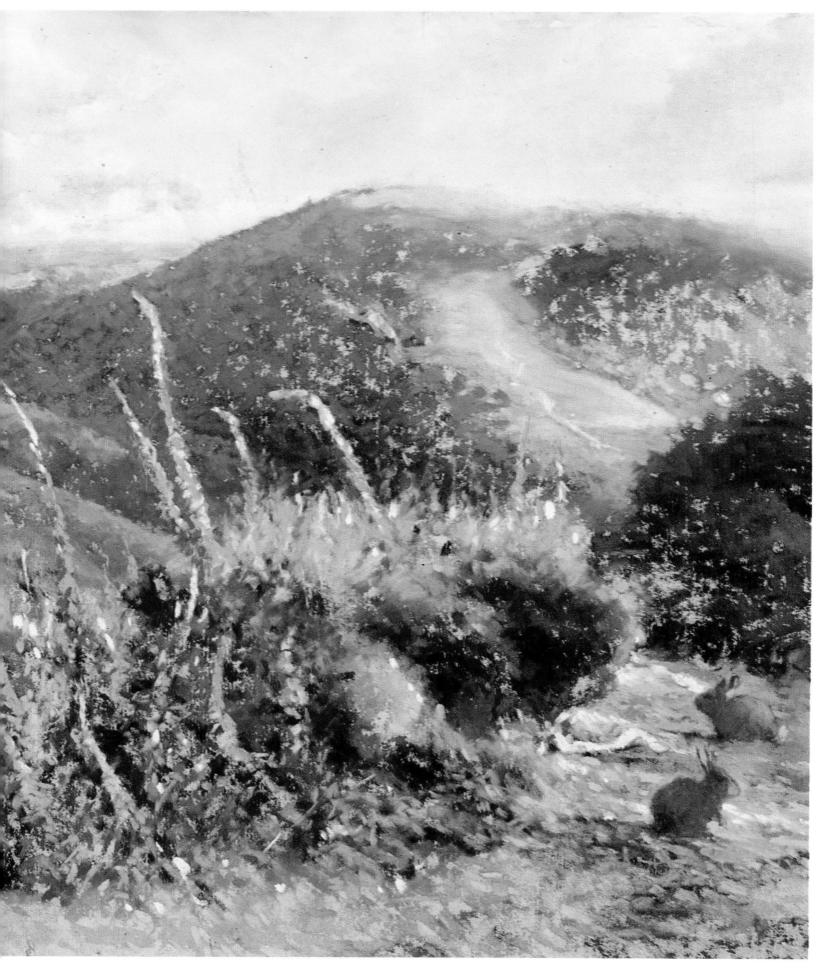

Any landscape provides interesting subject matter. The ditch flowing through the centre of the picture is enhanced by the telegraph poles reaching upwards to the storm-laden sky. Denis Barker's picture brilliantly records the atmosphere of this late autumn scene.

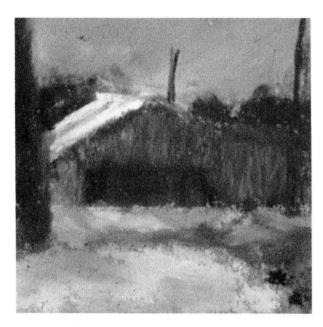

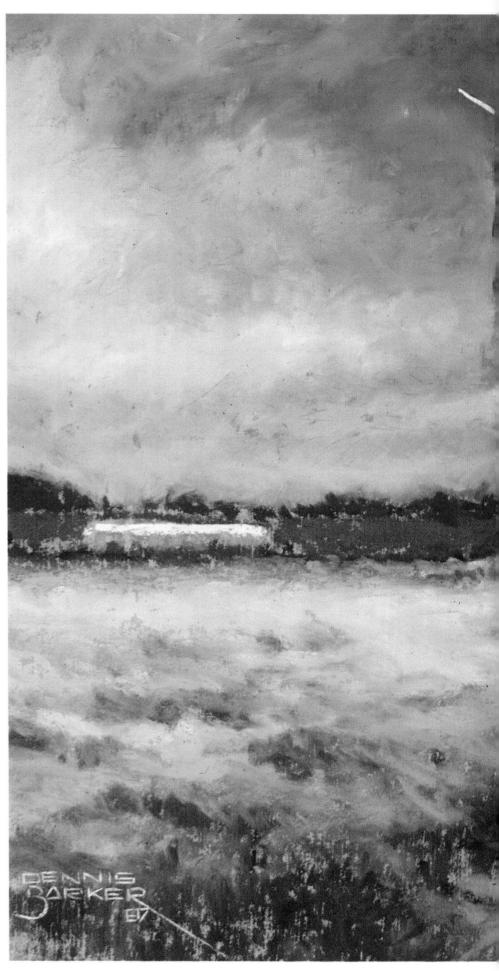

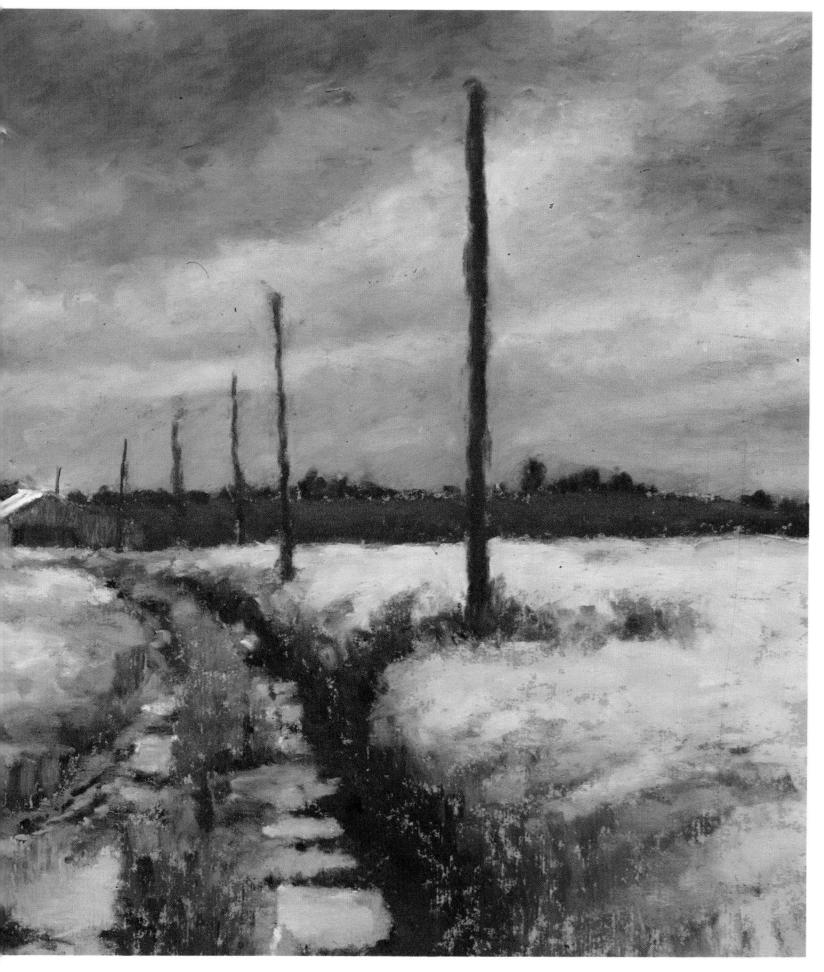

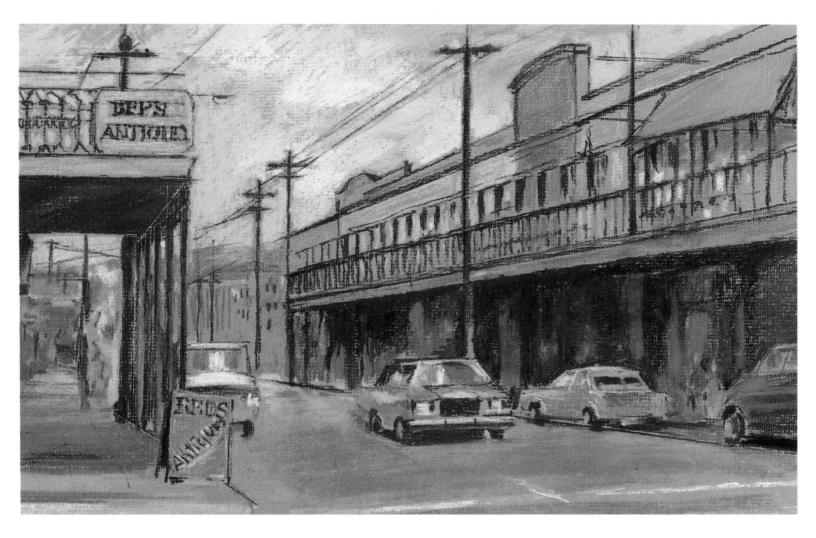

A New Orleans street scene offers an example of dramatic perspective. One of the important techniques used in any painting is not to draw the shapes but to draw the spaces in between the shapes. Details of the telegraph poles have been shown not by drawing them but by filling in the areas around them.

The same thing applies to the artist's method of rendering a car.

Oil Pastels Oil pastels are less versatile than water-based pastels, and are really a substitute for painting in oils. They can be softened and applied to the surface with a palette knife, and, like ordinary oil paints, thinned with turpentine. Perhaps they are most useful as an oil-painting accessory, though some people might find that they take to them better than ordinary

pastels, as they are denser in texture. They can be used on paper if they are employed in purely stick form, but if they are thinned with turpentine the paper will stain through, leaving the pastel surface dull. If paper is used, and the oil pastels are softened or diluted, it will need to be sized.

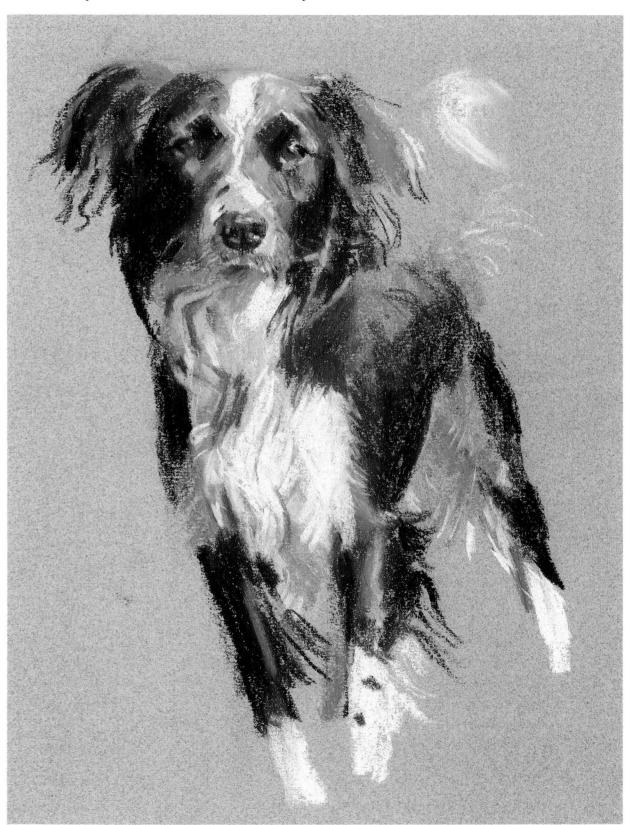

Oil pastels are excellent for capturing movement and for drawing animals as they do not smudge easily when the hand is moving rapidly over the surface. They also have the potential value of being used as a basis for oil painting later.

Figure Studies and Portraits

There is no better medium for figure work and portraits than pastels. In France in the 18th century portraits in pastel were brought to a peak of excellence, with beautiful skin tones and a luminosity and a freshness that persist to this day. Pastels do not deteriorate with age. If you want to improve your drawing the best way is to draw or paint the nude human figure; if you can do this you can tackle any subject, and the best way is to join a life class, perhaps at a night school. Do not be embarrassed or alarmed in case your standard of work is too low; no-one else is. Many people who go to art classes go as a hobby, some have been going for several vears, have never been or may never be much good, but no-one bothers. Art classes usually last about two hours; the first part of the session will be devoted to one or two rigid poses, but towards the end many art teachers organize five-minute poses for quick sketches, ideal for pastel work. And sometimes the need to finish off a pastel drawing in a few minutes brings out a hitherto unrevealed talent.

It is best to use a large sheet of paper, for if you are working on a small sheet arms and legs have a tendency not to fit in. There are many ways of tackling the nude figure: sketching in a brief charcoal outline and building on that; putting in with the flat of the pastel the background shadows, and depicting the figure against these; blocking in the main masses of the figure with a medium tint, then toning in the darks and then the lights; using a dark paper and starting with the highlights, working up to the mid-tones and the dark-tones. It is up to the individual. As in landscapes, only put in what you see, not what you know. Anyone can draw a mouth freehand and have it recognized as a mouth. But when looked at in a certain light the mouth may only be discernible as a shadow beneath the lower lip; the nose may be detected as a shadow shape on the cheek.

Again, it is up to the individual artist where to start. Some begin at the head, some a solid torso, building this up with tones and then adding the legs and arms, indicating them en route with tentative lines and patches of tone and colour. Proportions are more important than anatomy; a man is eight heads tall, a woman six heads, a one-year-old child four heads; the halfway point down of a man is the crutch. There are one or two tricky points – the neck does not rest on top of the shoulders but is inset slightly below. A man's neck slopes outwards, a woman's inwards. When drawing a hand, remember that unless it is extended the thumb droops. Watch where you put in the ankle; it can make all the difference between a convincing foot and one that falls short. Getting

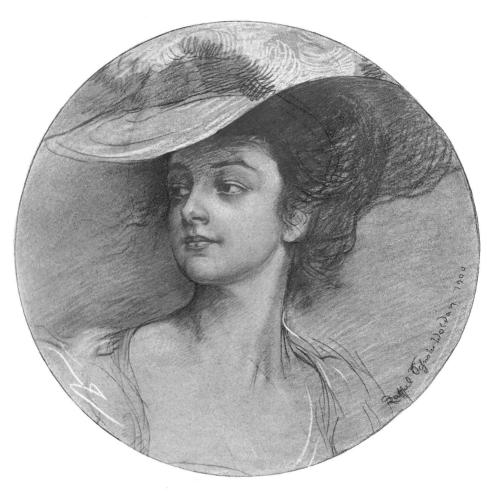

the proportions right is helped by holding the fist at arm's length and measuring up with the thumb. For instance, the body may be a threequarter thumb length; the legs a thumb length. If you prefer, use a wooden ruler instead.

Solidity is more important than accuracy. If the body looks as though it is made of cardboard the shading is wrong. The shading can be altered in a few seconds in pastel either by adding tone, or, if it is a dark paper, by taking off some of the pastel and letting the paper show through more. The shading can be 'moulded' by gently merging the pastel tones into each other with the finger tip. If you are more experienced with landscape than life drawing, look on the human body as a tree trunk in which the shadows vary according to the direction of the light (the French artist Leger interpreted human beings as a collection of cylinders, which may be going too far!)

If you have begun the pastel with a charcoal outline and are beginning to apply colour, it is worth remembering that you do not have to stop at the lines; you are not a child filling in a colouring book. Outlines, as we have seen, are a convenience. You use them when you want them. When they have served their purpose, as a preliminary basis, they are disposable.

In this portrait the artist has used a variety of pastel techniques such as the subtle combination of colour explained in the abstract diagrams on page 43.

Victor Ambrus's study Seated Girl with Hat is a splendid example of the use of a quick outline drawing with a broad, flat rendering obtained by using the side of the pastel stick to allow the background colour to show through.

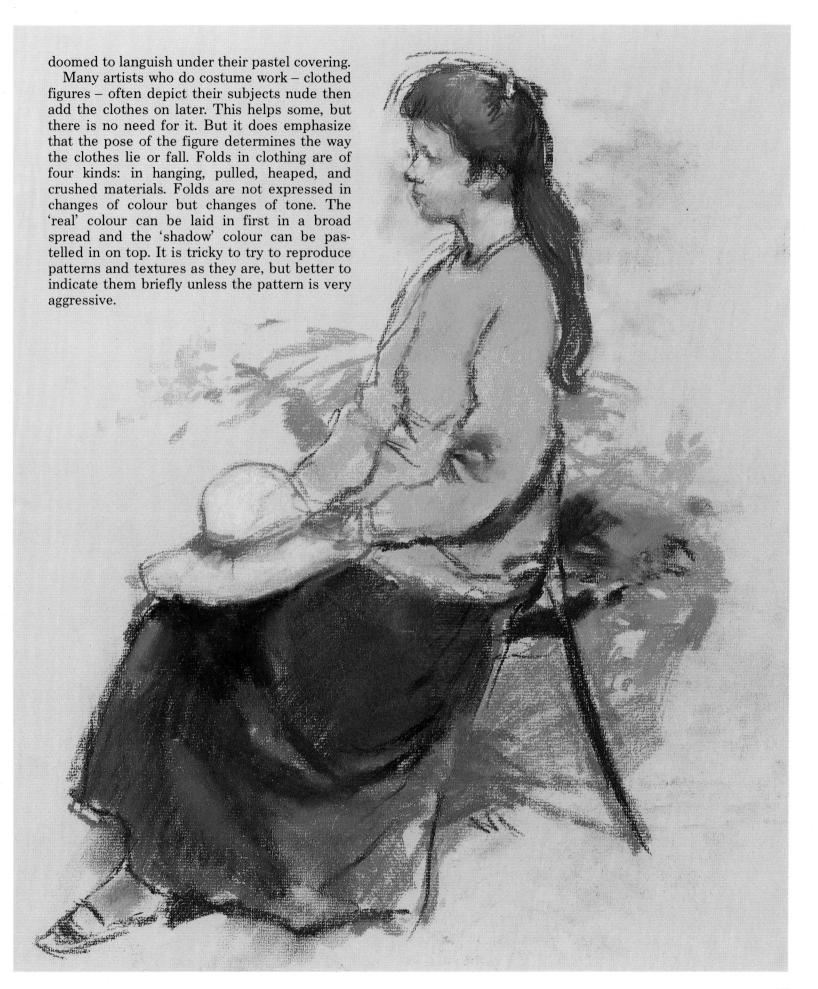

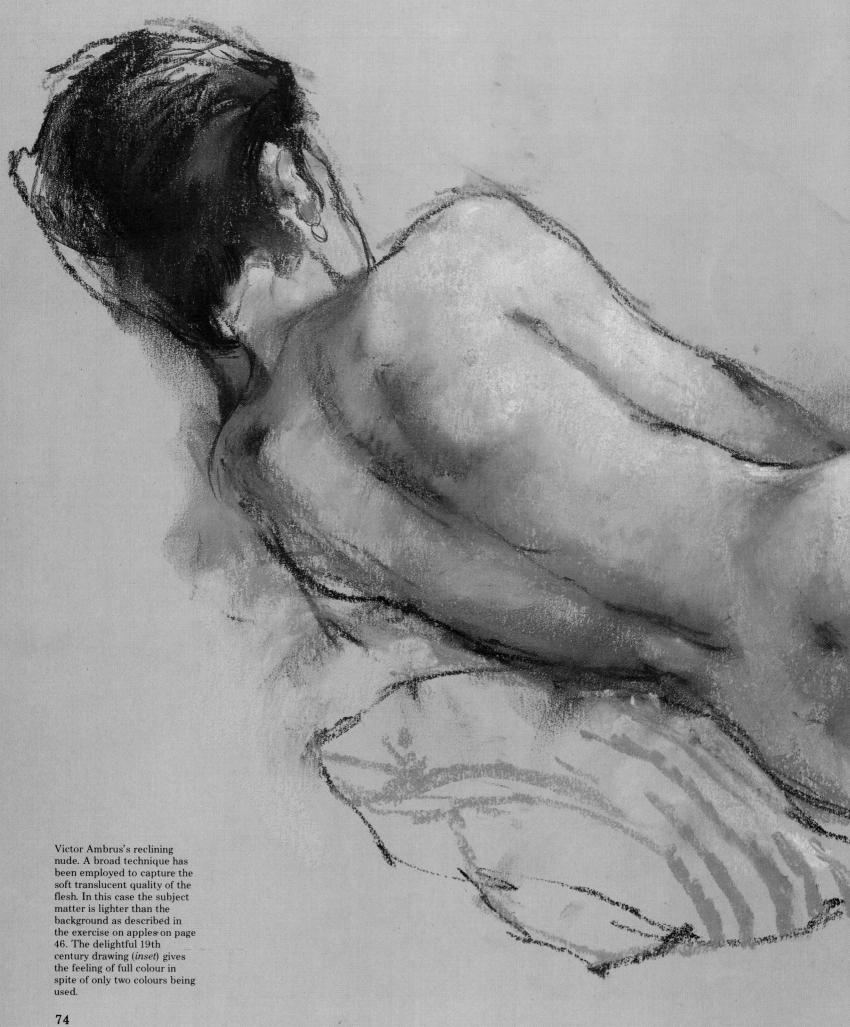

Of all the subjects, portraits are perhaps ideal for the pastellist, and it is easier to get models; all you need is a mirror and you have yourself, and you will probably not need to walk more than six feet to get expert advice as to where you went wrong (if you did). There are, as with figures, numerous ways to do a portrait, many ways to start. Many portraitists start with the eyes and, whether or not they are windows of the soul, a good eye can be a decided plus when the portrait is completed. The eye comes in three divisions - pupil, eyelid, eyelashes, not to forget the pouch beneath the eye. Always put a highlight into the pupil of the eye; it need not be dead centre, but make certain that it is in the same position in each eye.

One experienced portraitist, W. H. Allcott, R.W.A., R.B.A., described his method of work. He first drew the outline of the head in charcoal or black Conté crayon, choosing a threequarter view as this provided the best shadows. He then drew in the features lightly and fixed the shadows, which he toned in. Then with pale orange or yellow ochre pastel he drew lightly over the entire drawing, except the hair, using the pastel on its side and letting the paper show through. On this tinted surface he then used sepia to put in the eyes, nose, mouth, etc., and then filled in the mouth with vermilion or crimson. The shadows were then inserted, with definite edges, in brown. If the eyes were blue or grey he lightly tinted with those colours. The next stage was to indicate the lines of the neck, stressing the pit of the neck, very important for setting the head on the shoulders. Then the hair, first of all put in lightly, and built up. It was important to note the direction of the growth and the shape of the masses. That was the end of the sitting. He then took the drawing back to his studio and built it up from there, adding colour and tone, but he had the basics. The next day he would return, check his work, and make any alterations. He made the point that some newcomers to pastel find spectacles difficult; some artists add them later, but Allcott was not in favour of this, preferring to incorporate them in his first drawing, emphasizing the need to note the size of the lens and how far the bottom rim was from the wing of the nose. He found that the line of the frame from the lens to the ear was useful in estimating the proportion of face and head. Another method, equally commendable and used by practised artists, is to use a mid-toned paper, put in an oval shape in charcoal, and mark off the position of the features. There are various aids to this: the eye is halfway down the head, if the head is front on, the tops of the ears are level with the eyelid; the distance between the top of the forehead and the top of the nose is about the same as the distance between the top of the nose and the bottom of the nose. The distance between the top of the upper lip and the bottom of the chin is about the same as that between the top of the ear and the bottom of the ear. It is advisable to stress the word 'about' for the small variations - and they are small - is what distinguishes one person from another.

After the features have been set in, charcoal is rubbed in to establish light and shade, using a putty rubber to pick out highlights. Colour is put in from dark to light, keeping the pastel strokes loose and not putting in too much detail. Background tones are then put in, and where the figure abuts the background a light

The building-up of a head, using pastels. Here, the artist has worked from a sketch outline through to a very finished study.

colour is put around it, forming a discreet kind of halo. This helps to locate the subject in space, against the background. Warm tints are used for the face, using a grey of the same colour group to increase definition. Bluey greys are then worked into the hollows of the cheek, chin, and top of nose. Simple detail is introduced to the clothing, but the clothing 'tapers off' leaving a good deal of the paper blank.

The colours can also be applied first without preliminary drawing. The dark and warm colours are first loosely laid down, and then the lighter and colder colours are added, using the flat of the pastel and rubbing in with the finger tips if required. The work is carried out dark to light, and the outline is drawn in with a hard pastel. As the background is fairly thin in texture the hard pastel will take; there is no need to use black. Brown or red are sometimes preferred. Add colour to the parts, shadows and dark tones first, using the finger sparingly or not at all. The colour of the paper of course can be fully utilized. A good paper colour for a portrait is yellowish or warm brown; both impart a cheerful character to the picture. Grev is also good, giving a quiet effect, but blue is not recommended for portraits as when the first colours are put in they appear warmer than they do later when the whole of the painting is coloured in. To keep the face clear of the background, the tone immediately round the head should be darker than the half tones of the face but lighter than the shadows. A good way of applying one colour over another is to apply the first diagonally, letting the paper partly show through, and then apply the second colour, also diagonally but in the opposite direction. These tones can be blended with the finger tip.

This series takes the student step by step through the development of a portrait.

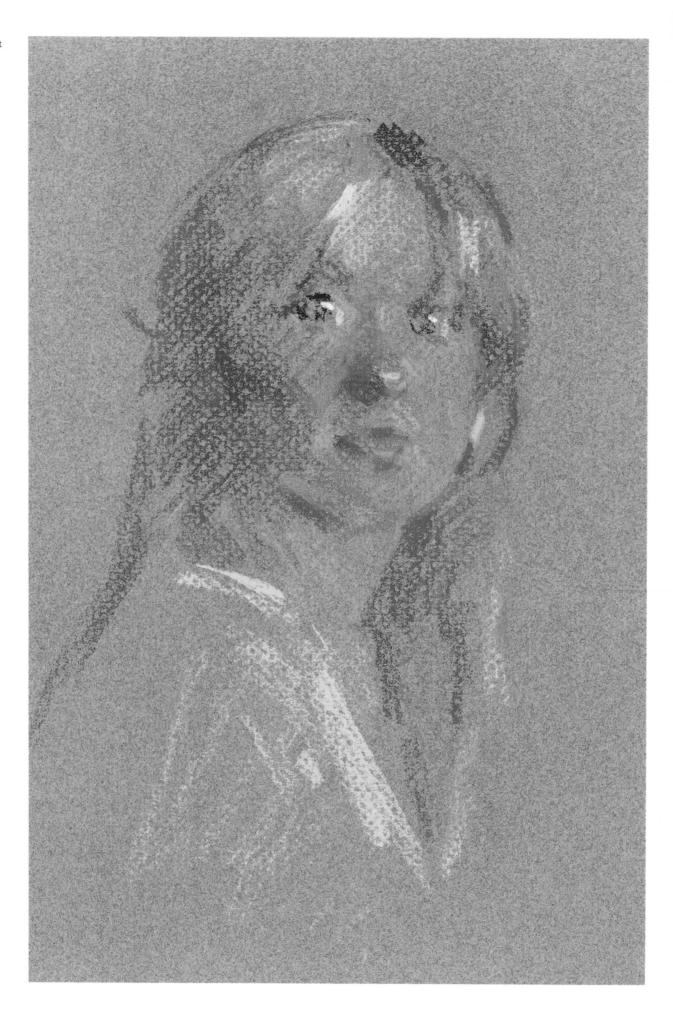

The picture is beginning to develop. The artist has paid more attention to his colouring and tone rather than to the sketching of the detail.

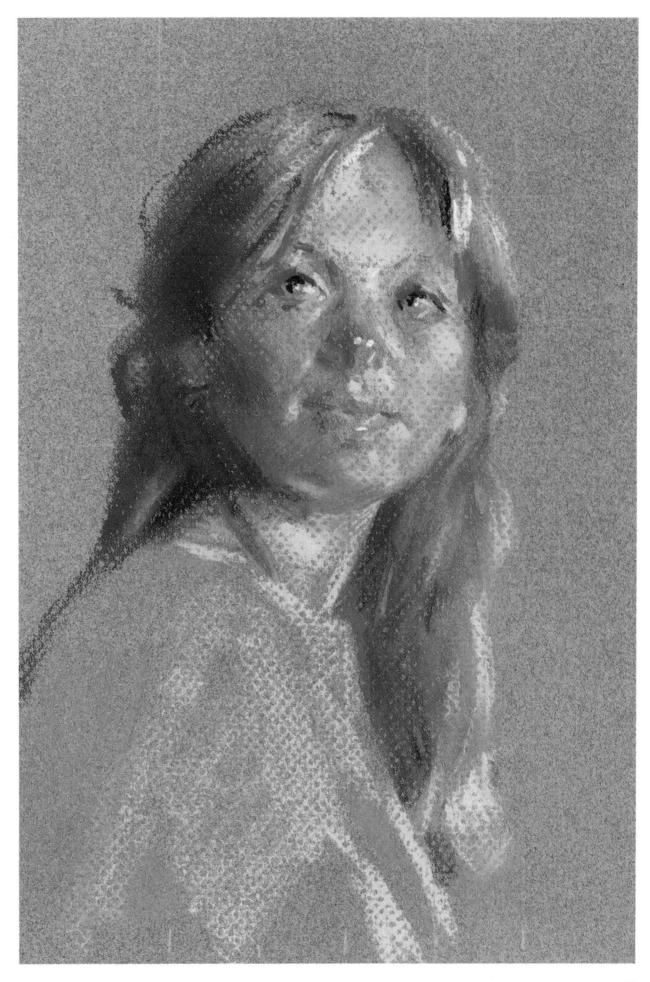

Choosing a background colour (as previously described) darker than the subject matter enables the pastel to illuminate from the negative colour background. The artist has broadly, with a brown colour, sketched in the darker areas and has suggested the shape and position of the subject with other colours.

The portrait is very near its completion. The colour has been built up not by one but by several applications of colours and the finger is used to merge in the soft tone.

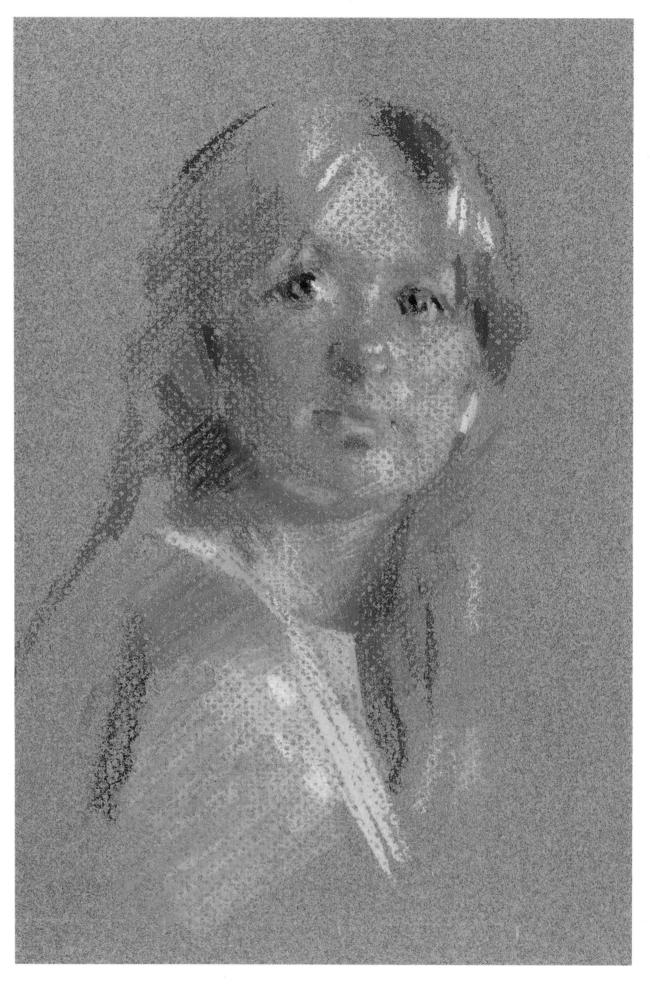

The final picture is brought to life by the application of darker and lighter tones. Note that the only white used is on the highlights of the nose and eye.

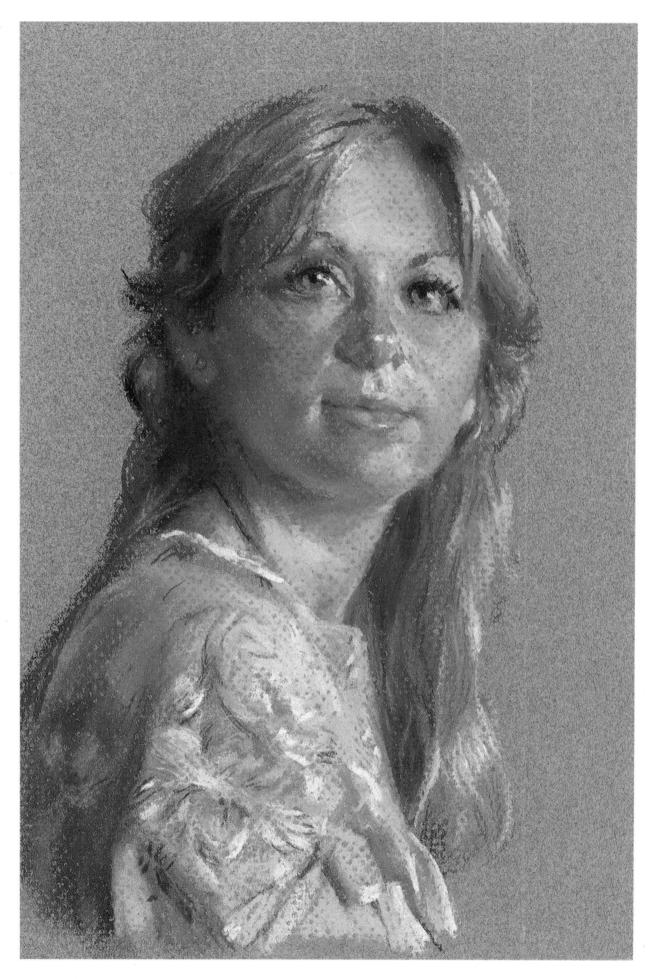

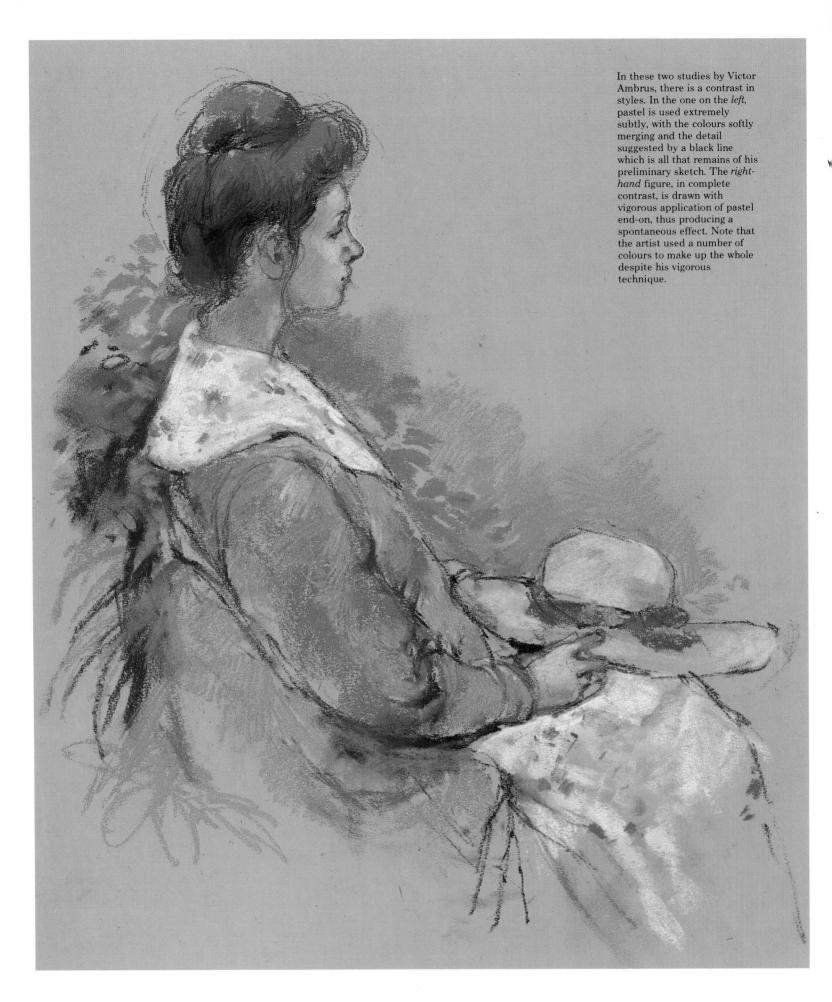

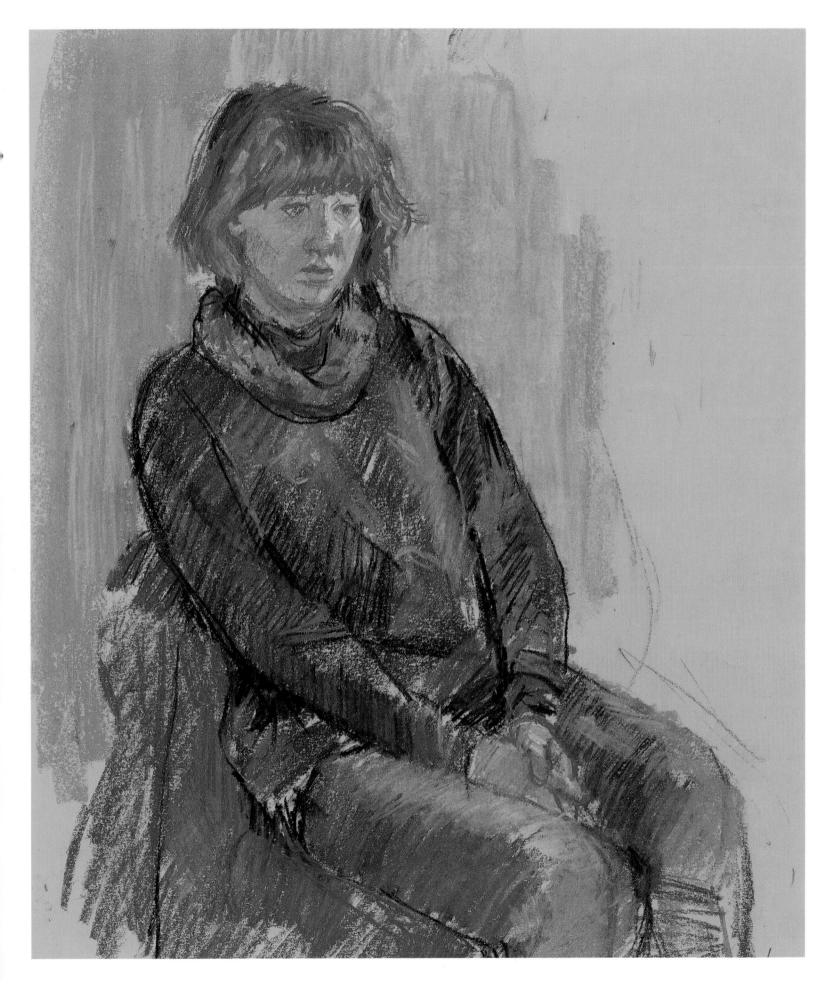

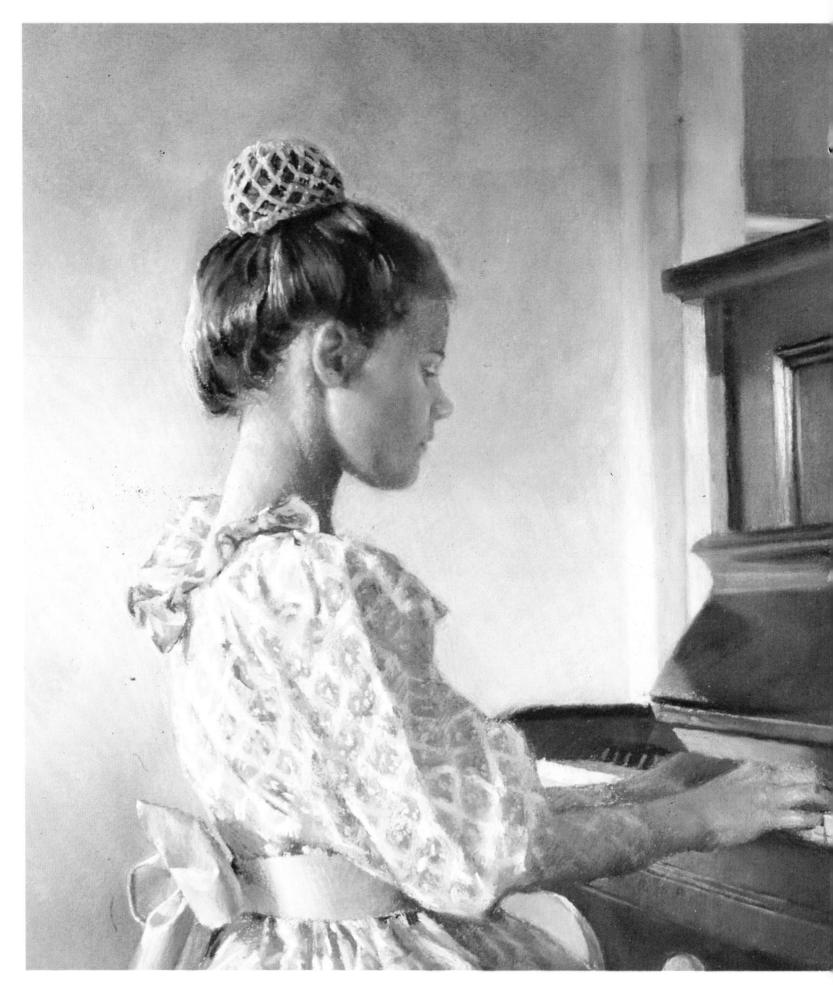

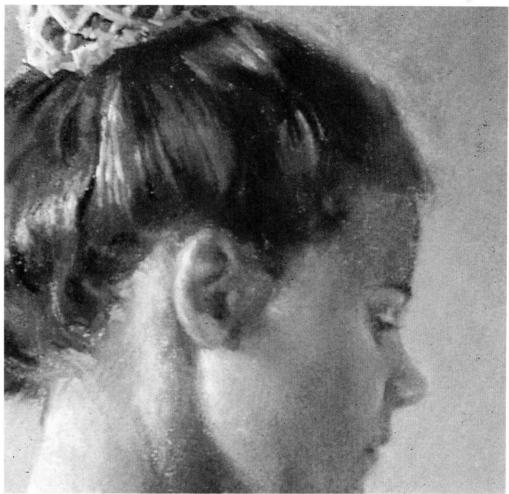

Girl at the Piano by Ken Jackson. All the techniques previously described have been used to make this delightful composition. Interestingly, the artist has chosen to draw the figure pointing away from the light source.

Above: In this detail you can see that the softness of the face has been achieved by massaging the colours with the finger and using darker colours to suggest the detail.

Left detail: Although hands are said to be difficult to draw, the artist has suggested the detail of fingers by his subtle use of lightness of tone and colour.

Finger painting is another option. The head is sketched in in charcoal on smoothish, fairly dark paper, and flesh colours such as yellow ochre and vermilion are put down on a separate piece of paper. These are taken up on the finger and applied to the light parts of the face such as the cheeks, forehead and chin. A brown or black pastel (brown is warmer) is then used in the orthodox way as a drawing instrument to emphasize the shadows, but the features are only suggested, and the paper is left for the half tones. Then, using the finger again, a little white is added to the flesh colour and the highlights are put in. This can be carried to any degree of completion. When doing portraits it is wise to stand back from the picture from time to time, assessing how it is going, and the same is true of figure studies and still life.

If you can do a good portrait in pastel you will never have any lack of sitters; and some of them will eagerly pay to have their likenesses done. The artist William Rothenstein wrote many wise things about the art of pastel portraiture:

'The success of a portrait drawing depends on many fortuitous things, as the quality of the paper and chalk; on the artist's mood at the time; but mostly on the sitter, for the sitter helps to make or mar his own portrait: some the moment they pose excite one's pencil, others paralyse the will, one cannot keep a pose; others, especially old people, must be kept interested. Men, equally with women, wish to appear other than they are – the mirror will not lie, but the artist must be persuaded; yet if he compromises over form,

his drawing will suffer.'

Of course the various pastel techniques can be used on other subjects, such as still life and animal pictures, which offer enormous scope to the pastellist. Fur and coat is ideal, and there is no better way to reproduce rabbit hair than a mixture of grey and white blended together with the finger tips, and then overlaid with strokes drawn with the corner of a pastel stick. Easy creatures to draw are rodents, which can be taken in at a glance and can be blocked in immediately with pastel used on its side without the need to do a preliminary charcoal sketch. A useful tip is that the torso and legs of many animals such as a dog and a cow fit into a perfect square. When drawing animals remember that they have necks! The right proportions are vital for good animal studies, so use photographs and other illustrations to ensure that you get them right, if necessary using a pair of dividers to compare dimensions. The legs are important. When drawing a dog remember the peculiar shape of the back leg. But once you get it right you will always know in future where you have gone wrong.

Because of their bright colouring birds are delightful subjects for pastels, but it must always be remembered that what might seem a change of colour is a change of tone. Feathers are rarely effective put on one by one; it is better to insert them in batches, aware that these sections of feathers shade those below them. Bright colours are not sacrosanct, and often they must be amended to make them hang together in all types of picture and in all mediums.

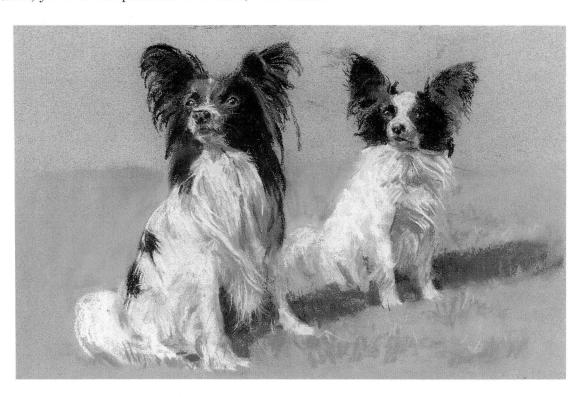

Pastel is an excellent medium to use for drawing animals. A few broad strokes is all that is required to suggest fur.

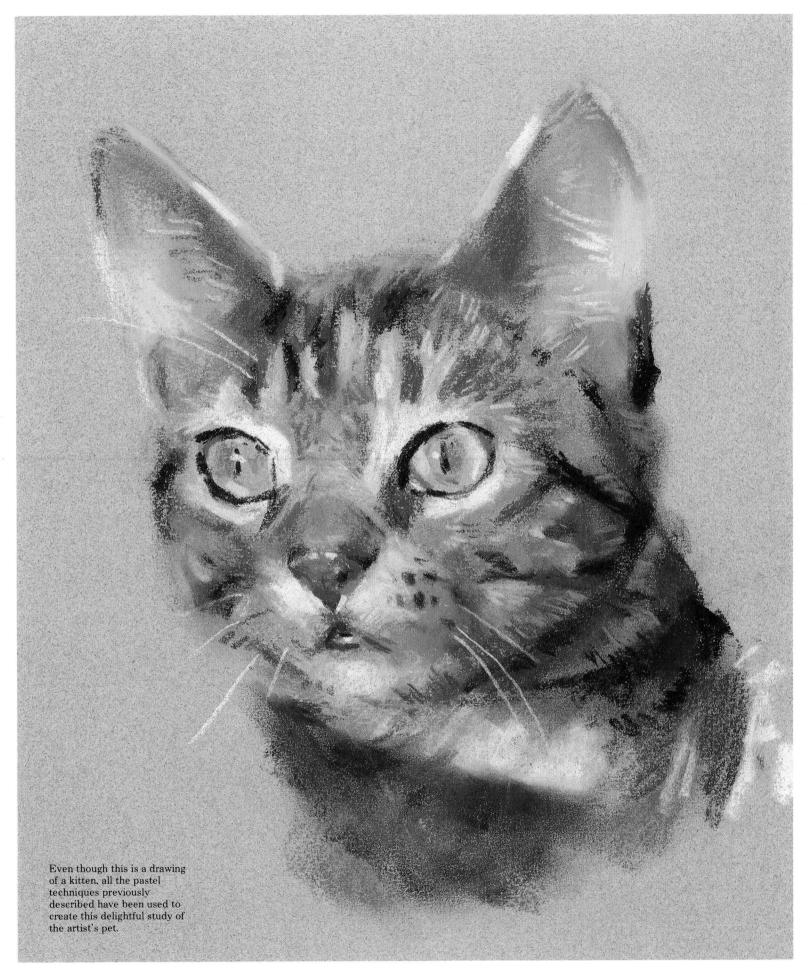

The advantage of still life is that you retain control of the subject matter and composition. The illustration (far right) shows an interesting grouping of flowers and cup. The quality of the light is the key ingredient of this study.

Still Life and Flowers

The above also applies to still life and flower pictures, where the hues may need to be altered, sometimes drastically, sometimes subtly, to create a picture which is all of a piece. More even than in landscape still life pictures need a focal point to which the eye is drawn; it is sometimes known as an anchor, and colour and tone help. Various techniques can be used to set down a still life – charcoal outline, broad masses with the tones added later, putting in the shadows first and laying the objects against it. If a still life picture remains a collection of objects without rhyme or reason it can be very boring. So how do we bring all the objects together to make the picture work?

By manipulating colour. Suppose you have a group of objects including a white cup. How do you depict the gleaming highlight on this cup? If you paint the cup its real colour, where is the highlight? Nowhere, for it cannot be seen. White against white does not go. So white must be reserved for the highest note in the picture, the highlight, and the cup must be painted grev. There is no other way. And with this highlight in, it must be protected. This may mean muting the yellows to greens, the reds become browns and purples, and the blues are put down as dark greys or blue-blacks. Because articles in the picture have to be toned down, so will the background, which will be undifferentiated so that it will not detract from the low tone elements in the picture.

Altering colour in this manner exercises not only observation but taste, and the great advantage with pastel is that experiments can be carried out without pausing, as would be the case with watercolours and oils where you may sometimes have to take into account the damp paint surface and wait for it to dry.

Many flower painters endeavour to represent every flower, stalk, and leaf as an identifiable botanical specimen, and this is all right if it is your favourite approach. But the accumulation of detail can be counter-productive, and can result in lack of atmosphere, colour clashes, and an absence of harmony. The background should be that, and not intrusive; blooms or leaves at the edge of the field of vision should be allowed to take second place by using muted colour and by softened edges. Some pastellists advise that the focal point should be painted in full colour and the passages of secondary interest should be pastelled in in quieter tones.

To get three-dimension roundness not only in flower paintings but in still life, figures, and portraits, you may need to tone down those surfaces which are receding. For example, in a face lit in front, the cheeks are seen as receding planes and so their edges must be subdued in tone otherwise the face will seem flat and uninteresting. This toning down can be done by smoothing with the finger tip or by using intermediate colours to bridge the gap. In flower painting, a yellow flower receding against a blue background would need a narrow band of yellow-green or a very muted purple adjacent to the yellow and a band of blue-green next to the blue background. Regarding the proportion of strong colours to neutral colours, an old recipe was to allot two-thirds of the paper to neutral colours, one third to full colours.

Two illustrations of the cup in the main picture show the difference in the quality of light. The picture (*left*) has been drawn in stronger light, i.e. coming from one source such as a window. In the other illustration the effect of the light is more subdued.

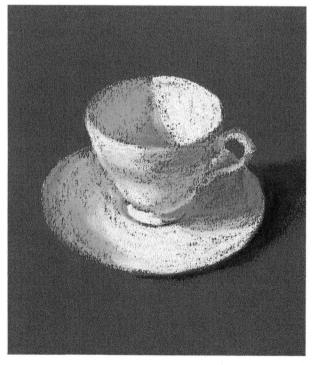

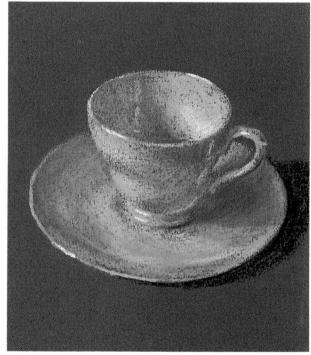

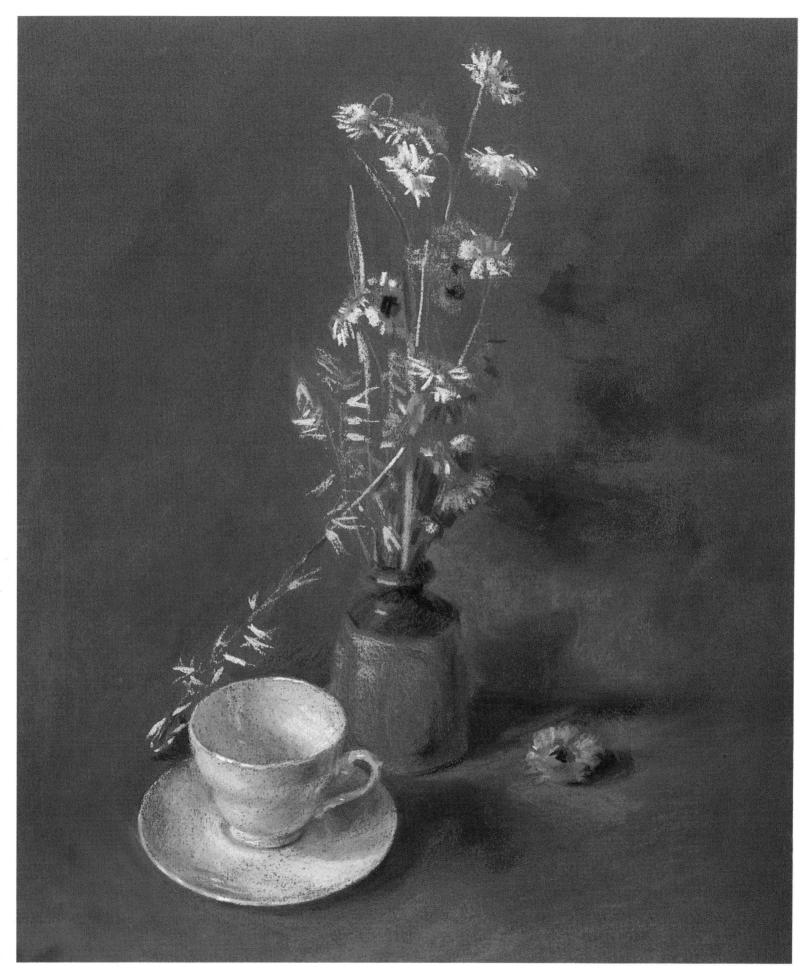

Closing Stages

Having reached the stage where the painting is coming along nicely, you should check that the picture hangs together well, and that the colour combination is right. The objects should look real and solid, and the light and shade realistic. The shadows should not be too harsh; if they are too black add in a lighter colour. If you want to focus attention on just one part of the picture (for example a face in a portrait) gently blur the edges of features you want to demote. If you want to highlight something, add a fleck

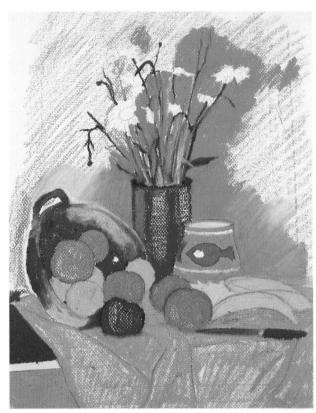

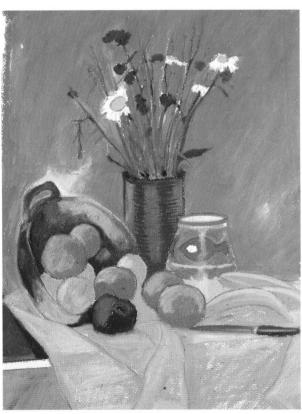

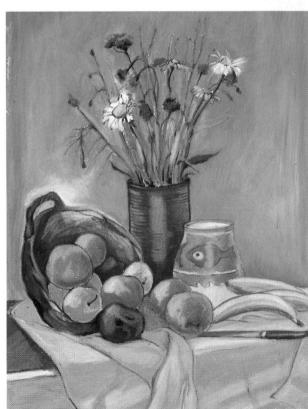

of white. If you consider the picture finished hold it upright and gently tap it on a table to get rid of surplus pastel dust. Then apply the fixative. Fixative can be applied at *any* stage throughout the painting, and pastel used on top. It is not a varnish.

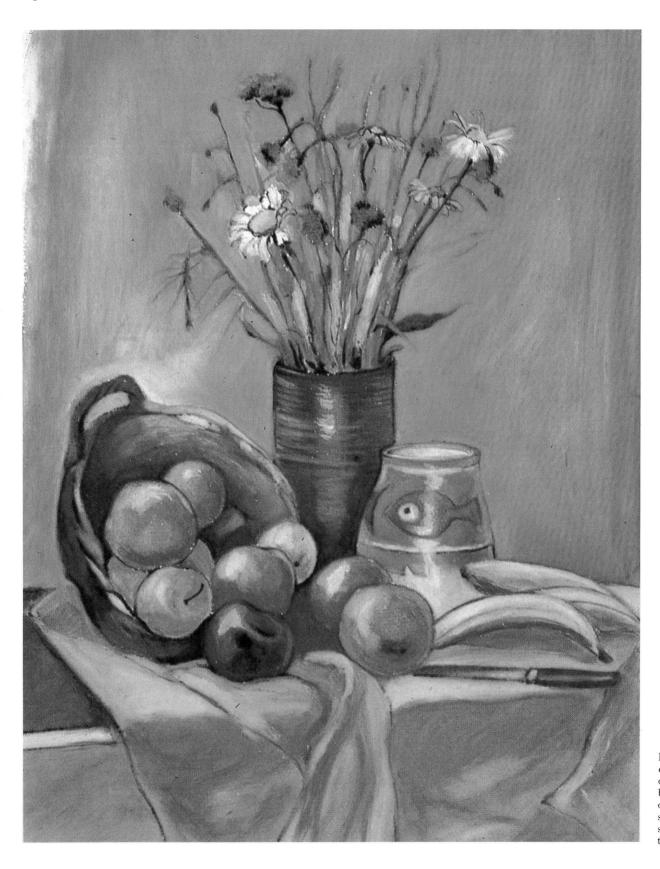

In this still life, the artist has chosen very brightly coloured objects with a bright background. He has used an outline, rather than the suggestion of shadow for shape, and has finger-blended the pastels.

Your local picture framer will have ready-made frames for you to choose from. If not, he will have many mouldings and mounts that can,

inexpensively, complete your work

MOUNTING AND FRAMING PASTELS

Some people draw a margin round their paper before they start doing a pastel, and keep their picture inside this inner area. Others use what area of paper they want, and consequently the subject matter is not necessarily in the middle. A number of mounts should be kept handy, so that when the picture is completed a mount can be placed over it to see what needs to be in and what is superfluous.

Pastels can be framed like water colours, with a cut cardboard mount to keep the picture surface off the glass. Large pastels tend to crinkle if mounted free, and should be pasted down on mounting board using wallpaper paste.

The pastel is placed face down on a pad of newspaper, the back moistened with a large soft brush, and then put on one side while the mount is pasted. The pastel is then placed snug against the mounting board, making certain that there are no air pockets. Suitable mounts can be cut using a scalpel or craft knife.

Pastels can also be framed without using a cardboard mount, in which case a fillet of wood or card (known as a 'slip') is fitted round the edge of the inner frame so that it separates the pastel from the glass. Even after the use of fixative, a certain pastel-powder loss must be expected if the picture is directly against the glass. Pastels do not fade, nor are they subject to mould. If pastel pictures are stored they should be interleaved with tissue paper; there is a slight powder loss, but of no great consequence.

Publishers' Knoup \$15.98, 5/99
FISKE FREE LIBRARY
108 BROAD ST. CLAREMONT, NH 03743